STATELESS:

DIARY OF A SPIRITED BOY AT NAPHO CAMP

SANVA SAEPHAN

PARTRIDGE
A Penguin Random House Company

Cover by Ong Yu Xin
Picture by Amanda Lau and unidentified source from Facebook

To order additional copies of this book, contact
Toll Free 800 101 2657 (Singapore)
Toll Free 1 800 81 7340 (Malaysia)
orders.singapore@partridgepublishing.com

www.partridgepublishing.com/singapore

Praise for Stateless

~ ~ ~ ~ ~ * * * ~ ~ ~ ~ ~

"Appropriately chosen insights into the arduous life of a Mienh refugee family from a child's perspective take the reader on a journey through years of utterly trembling uncertainty, ground-breaking decisions and delightful moments of joy, never losing sight of the silver lining."

~ **Prof. Dr. Matthias Neu, Germany**

"A mixture of memoir, cultural observation and social history, 'Stateless' by Sanva is a unique portrait of Laos. It gives an exceptional chance to enter the mind of another and see the world from a strange and fascinating perspective."

~ **Sidhant Jain, India**

"Warm, insightful and charmingly written, it takes you on a walk in the shoes of a stateless boy as he grows up in a time of uncertainty."

~ **Yang Yan, Singapore**

"Who knew living in a refugee camp could be so much fun? Sanva continues to be as spirited as the boy in Napho Camp with selfless dreams backed by concrete actions. Well done."

~ **Johann Dy, the Philippines**

"Sanva encapsulated his scenic childhood life in Napho Camp with such a strong message conveying that genuine curiosity, the desire to learn, happiness and hopes are the keys for success. This book is just truly inspirational."

~ **Khatthanam Chanthabouala, Laos**

"Fascinating diary! If this diary was a dish, it has all the ingredients I love. Sanva's father is a filial son who would not abandon his own father regardless of how much unhappiness built in his heart; Sanva's mother is a wife who values love over material happiness. This doesn't have to be the story of Sanva. Any story that has these characters with these great hearts will get my utmost respect!"

~ **Yun Lin, the USA**

"When I first met Sanva, he came across as someone who has an irrepressible enthusiasm for life. Despite the humble circumstances in which he grew up, he has a good sense of humor, a very strong sense of purpose and a determination that is really admirable. This is a delightful diary to read. The memories of his childhood and the details in which he remembers all the events amaze me. It is written in a simple, sincere style and the little stories are mesmerizing. Sanva's dreams are never selfish. They are always filled with the nobility of a very principled person whom I have such a great privilege to come to know."

~ **Esther Lai, Singapore**

"What a heartwarming story that evokes the nostalgia of a Mienh refugee child! It captures all the ups and downs, all the carefree moments, all the corruption and conflicts, which the young Sanva had to face with his family and friends in Napho Camp in the early 1990s."

~ **Friedrich Neu, Germany**

"An animated self-narrative of the real life of a boy in a refugee camp, packed with astute observations and unordinary experiences of everyday events."

~ **Prof. Tomoki Fujii, Japan**

About the Author

~ ~ ~ ~ ~ * * * ~ ~ ~ ~ ~

Sanva was born in a refugee camp in Thailand. He then migrated to Bokeo, Laos, at the age of seven where he and his family were given Lao citizenships. At the age of fourteen, he was given the Lao-Kumamoto scholarship to live and study in Vientiane High School in the capital of Laos.

Shortly after, he was offered the ASEAN scholarship at the age of sixteen to study in Singapore. From 2003 to 2012, he went to Xinmin Secondary School, Meridian Junior College and Singapore Management University (SMU) for his education. Sanva now works at Credit Suisse in Singapore but his love for his homeland and her gentle people remains undiminished.

Acknowledgement

~ ~ ~ ~ ~ * * * ~ ~ ~ ~ ~

This *Diary* would not have materialized without the support and encouragement from the following individuals who read my manuscript and gave me so many invaluable insights on how I should structure this *Diary*.

To Ms Tan Siew Sang, my English teacher, you are the main force behind this *Diary*. Because of you, I decided to compile the entries in all the diaries I have kept through the years into one volume. Without your commitment and selflessness, this *Diary* might not have seen the light of day. To Ms Esther Lai, my Junior College Principal, you are simply amazing. Your simple words of encouragement made me realize that I should share this with my readers.

To Drs. Kor van der Helm, thank you for taking time off to write the foreword for my book. I am very grateful for and humbled by your support and words of encouragement. Your foreword has definitely propelled this *Diary* to a higher level. To Prof. Tomoki Fujii, your words of encouragement have always made me believe that I am not alone in this journey.

To Christopher, my best friend, you have always been my pillar of support in so many ways. I do not think I can find any friend who can be so understanding and supportive like you. You are always sincere and genuine, and your honest feedback helped me a lot in organizing my thoughts in this *Diary*.

To Yu Xin, my mentee, without your amazing graphic design skills, this *Diary* would not have had this hauntingly evocative cover page. Without a single word, you were able to capture exactly and eloquently what this *Diary* is about.

To Winnie Cheong, my ex-manager in IBM and my friend, your enthusiasm and optimism have gone a long way in shaping the marketing strategy of this *Diary*. Without your wonderful ideas, I would not have been able to get the foreword and reviews for this *Diary*.

To Ms Tan Siew Sang, Winnie Cheong, Xing Yan Chia, Yang Yan, Lin WJ, Johann Dy, Friedrich Neu and Usha Kumaran for helping me to proof read this *Diary*, thank you very much. And to everyone who provided comments and praises to this *Diary*, I truly appreciate your great help and time.

Finally, to Ashley Ang, the editor of this *Diary*, you are fantastic. You are both my senior and good friend. We had lost touch for about five years but when we met again, the connection that we had was still as strong as

ever. Back in our Xinmin Secondary School days, your creative and beautiful narrative essays greatly helped me improve on my writing. And because of that, I managed to pass my English exams. I am so glad that our paths crossed again.

From the bottom of my heart, thank you, everyone! You are the force behind this *Diary*.

Note to My Childhood Friends

~ ~ ~ ~ ~ * * * ~ ~ ~ ~ ~

To my childhood friends, in my account of our many wonderful escapades, I might have inadvertently mixed up some of your names, as the mind is an inexact repository of memories. If I have got you mixed up with someone else, my heartfelt apologies. I have tried to find ways to find you but so far to no avail. If you happen to read this *Diary*, please contact me and we will sit down to reminisce about all the good and fun days we shared. Let's walk down the memory lane one more time together.

Foreword

~ ~ ~ ~ ~ * * * ~ ~ ~ ~ ~

This *Diary* reveals the memories of an ex-Mienh refugee, Sanva Saephan. He was born in Ban Vinai, a refugee camp in the Lei Province of Thailand. Most of the stories are derived from the time Sanva lived in Ban Napho, a refugee camp near Nakhon Phanom. It is a fascinating story from a young boy's perspective.

The central theme of the *Diary* is: "*One thing you have to learn in life is not to abandon your parents, your loved ones and those who are good to you.*" This notion pops up in almost every chapter and shows the influence our relatives and ancestors have on our day-to-day decisions.

It is very interesting to get more understanding of the living conditions in a refugee camp like Ban Napho. How dignity, decision-making and so many more aspects of the Mienh culture have been experienced and questioned by a young child is captivating.

Before Sanva Saephan was relocated to Bokeo, Laos in 1994, he elaborates especially on aspects like the roots of the Mienh culture, family-ties, name-giving, school-life, health issues, camp-life and behavior.

From the time I worked for ZOA Refugee Care in Southeast Asia I remember the dilemmas refugees faced,

when they had to decide whether or not to migrate to a western country and the prospect of seemingly certain prosperity. However, although the largest refugee migration may appear to many to be from Southeast Asia to the United States, actually the most significant and impacting migration for most of the refugees occurred from highland Laos to the refugee camps in Thailand.

This *Diary* reveals the reasons behind the Saephan family's decision to stay in the camp and after many years to return to Laos again. The relatives of Sanva Saephan made the decision not to go to the United States, in part because of the fear that the Americans would "eat up their people", a popular myth circulating among refugees who feared entering a different country and the eventual loss of their culture and language.

In those days there were a number of Laotian hill-tribe people residing in both Laos and Thailand. When feeling threatened or looking for better economic prospects, it was logical to move to those extended families across the border. At that time, it was illegal for people from Laos to cross the border and to reside in Thailand as normal citizens. However, when they were interviewed and found to be eligible refugees by the Thai and UN officers, they were allowed to stay temporarily in refugee camps across the border in Thailand. If they were not eligible refugees, they were ineligible to

be "sponsored" to the United States or other receiving countries. The ineligible refugees might have to be repatriated back to Laos.

Some border crossers married local citizens and became naturalized citizens in, for example, Thailand or Southern China. Most of them still reside there with their families today.

Some people were ineligible to come into one of the refugee camps because of their opium addiction. If they managed somehow to enter a camp they were requested to attend a detox-program.

For most of the refugees who chose to stay in Southeast Asia, the reasons for their decision varied from geographical disadvantages to ineligibility to enter the camps or to cultural bondage and family ties in the region. These varying reasons are significant in understanding their behavior. This *Diary* describes a particular reason for staying in the camps and returning later on to Bokeo, Laos. For the Hmong and Mienh families in the United States, it had a significant impact on their judgments and behavior, both mentally and economically, towards their relatives who had stayed behind.

Family separation has impacted the Mienh refugee families in various ways. The *Diary* reveals also some of the underlying discussions. Economic and mental independency has a very significant effect on the

Mienh refugee families, so is the mental strain from the inability to help family members in need. To not assist means an uncertainty of their family members' survival back in Laos, which could be a resounding message of helplessness.

Sanva Saephan is currently working in Singapore and he compiled this *Diary* from the dairies of his childhood. Through the sale of this *Diary*, Sanva hopes to raise funds for a much-needed school in his hometown Bokeo, in Laos. This is an admirable cause indeed, worthy of support.

Everybody who is interested in supporting such a meaningful cause or gaining an insight into different cultures should buy and read this *Diary*. It is an honor to contribute to this story of survival and to the Mienh society in Laos in particular.

~ **Drs. Kor van der Helm**
Hattem, July 16, 2013

Laos or America

~ ~ ~ ~ ~ * * * ~ ~ ~ ~ ~

My early childhood was spent fruitfully in Napho Camp at Nakhon Phanom Province, Thailand. All the memories I have of this camp flashed back like history unfolding right before my eyes as I was writing this *Diary*.

I was born in Vinai Camp at Lei Province, Thailand. Shortly after my birth, my family, together with other refugees, was asked to migrate to Napho Camp due to the closure of Vinai Camp. The United Nations (UN) was the main force behind this arrangement. Each time we were in a camp, we had the opportunity every four to five years to migrate to the US, France, Australia or

even back to Laos, depending on the current political situation. Some families were lucky enough to migrate to the US, France or Australia if they had host families in those countries willing to sponsor them. The sponsor families were usually members of churches or charity organizations. They were responsible for the settling in of the new migrants.

After the closure of Vinai Camp, not all the families could go to overseas. Some families moved to new camps while others moved to Napho Camp and waited for new opportunities to arise there. I lived in Napho Camp until I turned seven years old before my family and other refugees were relocated by the UN once again. At that point of time, my family was given a chance to migrate to the US like many other refugees. However, my paternal grandfather was not fond of the idea of going to the US, so we chose to return to Laos instead, the homeland of my parents and my grandparents.

My parents were born in Luang Prabang Province, Laos, which is now a UNESCO world heritage site known for its rich Buddhist culture. Elegant Buddhist temples are a common sight in the city. All the houses in this small, beautiful city still preserve their traditional architectural styles that truly appeal to Laotians and foreigners alike.

Choosing between moving to the US and Laos was a tough decision that my parents had to make. At that time, my grandfather was so adamant about going back to Laos that he did not really care if he had to return alone. I could hear my grandfather quarreling with his children practically every night.

"How many times have I told you that I am not interested in going to the US?" my grandfather would shout at the top of his lungs.

"Why would you want to go back to Laos to be a farmer there?" my father asked, looking straight into his father's eyes.

"What do you know about the US? How can you trust white people? They will cook you and eat you up!"

"But so many people have been there. Their lives are good," my father defended his stance.

"But these people may be bribed by the Americans to say good things. They may lie to you."

My father was momentarily speechless. He was deep in thought, trying to find ways to convince my grandfather.

After a fleeting silence, my grandfather vehemently raised a string of questions, "What can you do there when you can't speak their language? Do you think your English is good? Do you think they will give you free money?"

His tone of voice grew with angst and vehemence with every question hurled at my father. The last question ultimately ended with him stomping past my father. I quickly ran from my hiding place behind the door to hug my mother very tightly. I could sense that she shared the same fear I felt.

Silence engulfed the living quarter only to be broken when my grandfather furiously hurled a chair against the wall.

Uncle Saengfou, who was my step-uncle, then intervened. "Calm down! We can work this out," he said gently, pulling my father aside. He quickly stood in front of my grandfather with both arms widely extended, his back facing my father.

Both my father's and Uncle Saengfou's families wanted to go to the US badly as at that time everyone felt that life would be much better in the US compared to Laos. In terms of material living standard, it was undeniably true. That was the main reason why many people chose to migrate to the US. Also, because of the war led by Chow Lah (the Mienh leader appointed by the US) to fight against the Pathet Lao army, many Mienh people were afraid to return to Laos even though some of them had never participated in the war before. No one in my family had ever joined the cause but the Pathet Lao army's general assumption that all Mienh

were suspect at that time was enough to plant the seed of fear in every Mienh person.

In the end, whatever their personal feelings and misgivings, eventually, my father and Uncle Saengfou gave in to my grandfather's wishes. In 1994, we all migrated back to Laos to settle in Bokeo Province, the northern part of Laos.

Grandfather

~ ~ ~ ~ ~ * * * ~ ~ ~ ~ ~

From the time he was in Laos to the time he migrated to various refugee camps, my paternal grandfather married four wives.

According to my father, my grandfather's first wife passed away and left him in a state of depression for quite a while. A few years later, he was asked to marry his sister-in-law when his brother passed away because of sickness. At that time, his sister-in-law already had a son, who was Uncle Saengfou. The story told to me was that my great-grandfather could not afford to lose such a good daughter-in-law. Therefore, he forced my grandfather to marry his own sister-in-law. Thus she

became my grandmother and gave birth to my father, my aunt and another uncle. Unfortunately, this uncle tragically passed away when a tree cut by my grandfather accidentally fell on him while they were hunting in the forest. My uncle died trapped under the tree. Shortly after my uncle passed away, my grandfather stepped onto a landmine in the forest. Fortunately, he lost only his right hand.

A few years after my parents got married, my grandmother passed away due to illness. My grandfather's life at that time was not a smooth one as it was marred by many problems and tragedies. A couple of years later, he remarried but divorced when his new wife chose to go the US with other refugees and he chose to stay back in the refugee camp.

I was told that my grandfather had been cursed by the devil. According to an ancient predictive reading based on his date of birth, in his lifetime, all his wives would die before he did. In the past, it was a taboo to reveal this superstition. Therefore, for selfish reason, my grandfather and those who knew about this had to keep it a secret. If not, no girl would want to marry him. That was why my grandfather's true birthday was concealed from everyone, including the authorities.

Because of my grandmother's untimely demise, I never had a chance to see her. The only memory I had

of her was a faded photo of her standing beside my grandfather, dressed in a traditional Mienh costume.

I learnt from my grandfather that Mienh people were originally from China. Back in the mainland, we were called Yao, a term that was associated with barbarians. Over the years following our people's migration southwards, we slowly began to call ourselves Iu-Mienh. To others, we are also known as Mienh, a term that has been commonly used until today. We, Mienh people, have our own dialect and writing system. My grandfather kept a treasure of books and scripts of Mienh literature. They were written in Chinese characters, but like any other Chinese dialects, read differently from today's Mandarin. My grandfather kept all those books, hoping that one day someone might use them and pass them on to the next generation.

Sadly, Uncle Saengfou was not loved as much as my father and thus did not receive as much education as my father. In fact, he did not have a chance to go to school at all. Determined and hard-working, he learnt how to read and write Lao by himself. Fortunately, Uncle Saengfou, my father and my aunt respected and loved one another like one family. In Napho Camp, the three families lived side by side and never left one another behind.

It was in Napho Camp that my grandfather had an affair with another woman, who gave birth to a male

child. He was the same age as my younger sister, Meiva. In the past, such cases were not uncommon among the older generation. This woman, hence, became my grandfather's fourth wife, and also my unofficial step-grandmother.

Although my grandfather appeared fierce and stubborn, he was actually very generous and gentle if you knew him well. Whenever he earned money from selling the chickens he raised, he would bring his grandchildren to the market and buy us snacks and desserts. Because of our cramped living quarter in the camp, my brothers and I used to sleep with him on the same bed, where he would tell us stories about the time he and other refugees had escaped from war in Laos.

"Children, you know that life in the past was much more difficult and tougher than today. We had to go into the jungle to hide from the enemy. Above us, there were helicopters belonging to the US and sometimes they dropped bombs on the ground indiscriminately. If you were not careful, you would be killed. You could hear the cries of children ringing out from different parts of the jungle and sometimes parents had no choice but to abandon their children. I almost left your father behind as he kept crying inconsolably. I then stuffed a piece of cloth into his mouth to silence him. To my surprise, it worked. Although your father was still crying

with tears and snot all over his face, he could not make noise anymore. We tried to keep as quiet as possible so that our enemy could not hear us. If not, we would all be shot dead."

My grandfather paused for a while. I turned my face up to look at him. In the dim light of the candle, with its rays shining weakly through the mosquito net, I could see a change of expression on his face. When he saw me look at him, he patted my head and continued with the story.

"Sometimes, we just kept moving on and on without sleep for many days. If you were unlucky, you would step on bombs and risk losing your life. If you had a chance to sleep at all, you would even sleep on hard and dirty soil. Sometimes, it rained cats and dogs, and the whole place was extremely muddy. It was very cold!"

My second brother, Kaeva, had already fallen asleep. But my eyes were still bright as I stared at the dark ceiling. I was waiting for him to finish his story. Even though it was already quite late and my grandfather was supposed to get us to sleep, he still told us about his experiences. I listened attentively and excitedly, imagining myself there with him when all those scary incidents happened. As my grandfather went on with the story, something lingered in my mind; it was the sound of children crying in the middle of the night.

"What if I was one of them? Would my parents abandon me?" I asked myself. This thought stayed in my mind throughout the night. However, I continued to remain focused on what my grandfather was saying.

"The Lao government thought that we were supporting the US and trying to destroy the country. Therefore, they wanted to kill all of us. Many of us were unsure if it was a rumor or the truth. But the message was circulating fast around the village. Some people who lived in the more mountainous areas also received the same news. All of us were so scared that we would be killed. Therefore, we started to move out of Laos as fast as we could. Some of us burnt down our houses so that when the Pathet Lao soldiers saw the ashes, they would think that we had already been killed by some other soldiers."

"Oh my goodness! Why are the Pathet Lao soldiers so mean and violent?" I thought to myself. At that time, I did not know what Laos or Lao people were but I was unhappy with them for what they had done to the Mienh people.

"They made us move out of our hometowns and villages. They caused so many innocent lives to be lost," my grandfather continued.

Deep inside my heart, I felt pain for the children who had died while trying to escape. However, a second

thought came to my mind. "Did the Mienh people really support the Americans?" I asked.

"San, those were rumors. Not all the Mienh people were involved in it. We did not even know what and who the Americans were. We had not seen their faces before in our lives, what more support them? But later when we moved to Thailand, we found out that everything had been planned by the Americans. This war was known as the Secret War. The Americans were recruiting the Hmong and the Mienh living in the north to fight against the Pathet Lao army. But we lived in Luang Prabang, which was further south and unaffected. Nevertheless, the Pathet Lao soldiers thought that we were in cahoots with them and the Americans."

I was curious and asked my grandfather, "Why did the Thais allow us to enter their country?"

My grandfather paused for a while and then answered my question, "Oh, the Americans and the Thais were friends. We thought that since we were believed to be working with the US, we would be welcomed by the Thais as well. Therefore, we just tried our luck to move to Thailand without knowing for certain if we would be allowed to enter or not. When we reached the Mekong River, we swam across. The Thais on the other bank received us and have let us stay here since."

"At that time, there were many other Lao people, who had moved to Thailand too. We did not know why they had to move. I asked a man I encountered and he said they all wanted to find a place to settle in first as they did not want to be killed in the chaos. I also found out later that the Thai government allowed us to come to their land because they did not want us to join the communists that were moving aggressively into Laos from Vietnam and China. I guess that was why many people chose to come to Thailand instead of going to Vietnam or China where we were originally from."

My grandfather paused for a while and went on, "Oh I know. If you remained in Laos, you would be called by the Pathet Lao soldiers for an interrogation. If you were, for any reason, perceived to be guilty, you would be killed. Many times, the Mienh people that were called for an interrogation would not survive. Therefore, even if you were innocent, you would not want to risk your life by going for the interrogation. Because of that, we all had to leave Laos."

I finally understood everything. It was interesting how many Mienh people had moved to Thailand, trying to escape from the threat of death that may or may not have been real. It may have been just a rumor but everyone treasured their lives and went over to Thailand before the rumor turned into their worst nightmare.

From his story, I could guess why my grandfather did not want to go the US. He probably still abhorred the Americans who had come to destroy his homeland. My grandfather went on with his war stories until Kaova and I fell into a deep slumber. Kaova was normally quiet and did not ask much. I seemed to be more interested in whatever stories our grandfather told us and asked him many questions. I was usually the last one to fall asleep.

When I was five years old, my grandfather discovered that I grinded my teeth while sleeping. He said it was really loud, as if I was crushing a paper or a plastic bag. It continued on for a few nights until he suggested to my parents that I was possessed by some spirits. At that time, especially among the superstitious Mienh community, ancestral spirits and the paranormal were something that everyone believed in. As such, my parents carried out a ceremony for me by slaughtering a chicken as a sacrifice and inviting a shaman to come over to chant something that was incomprehensible, at least to me. The ceremony involved the burning of joss paper and dripping alcohol into small bowls in front of the chicken while the shaman was chanting and mumbling. In the midst of it, I was made to sit before the shaman. My mother used charcoal to draw a cross on my forehead. The ceremony was supposed to expel any evil spirits that were believed to be possessing my soul. It

looked like a Taoist religious rite but I was not too sure. I guess it was more like animism. After the ceremony, I still continued to grind my teeth when I was sleeping at night. Therefore, everyone forgot about it after a while, and I still continued to grind my teeth occasionally.

Father

~ ~ ~ ~ ~ * * * ~ ~ ~ ~

In both the Vinai Camp and Napho Camp, my father was very active in helping out with the UN's missions. With some knowledge of English, my father was chosen to be a translator for the people who wanted to migrate to the US. Those refugees were required to clear a few rounds of interviews before their applications were approved by the American and the UN officers. As such, my father and a few other translators played a very crucial role in the whole immigration process.

You may be wondering why my father was able to speak English at that time. Like any other far-sighted parent, my grandfather realized the importance of education and

sent my father to school when he was in Laos. That was before they moved to the refugee camps. My grandfather earned his income mainly from opium farming. Part of this money was used to send my father to school.

My father was sent to a government school that used Lao as the medium of instruction. Besides that, my grandfather also sent my father for Chinese and English classes. At that time, there were some Chinese missionaries who had travelled to and decided to settle in Laos. Once they married local women and settled down, they started to teach Chinese. This was how they earned some additional income as they continued with their missionary work.

As for English, my father learnt it from a few Hmong masters. In all the refugee camps that my father had been through, the Mienh and Hmong always lived in close proximity to one another. However, until now, I am still puzzled by how the Hmong masters that my father learnt from had learnt English themselves. Whom and where did they learn it from? Unfortunately, when the family migrated to the refugee camps in Thailand, my grandfather's family faced financial difficulties and as a result, my father had to quit attending English classes. My father was heartbroken. He enjoyed studying languages. In fact, he was a very ambitious and hard-working person so this news saddened him indeed.

Fortunately for my father, his good friend, Uncle Yun Lin, funded his English lessons. Uncle Yun Lin was from a relatively wealthy family. His father was a Chinese trader who had travelled from China to Laos selling clothes and spices. He had then fallen in love with the land and settled there. In Laos, he met a Hmong lady and decided to tie the knot with her, and thus Uncle Yun Lin was born. His family was subsequently affected by the war and they had to migrate with the other Mienh people to Thailand.

In Thailand, my parents and other Lao refugees, mainly Mienh, Hmong, Khmu and other minority ethnic groups, stayed in a few refugee camps in different provinces. They were relocated once every couple of years. When they moved to Vinai Camp, there were a lot of uncertainties. People speculated about the imminent relocations. There were not enough teachers in school. Therefore, my father had to quit school at primary 4 and became a teacher earning about THB 500 a month for a couple of years. My father was about fourteen years old when he became a teacher. In those days, if one could graduate from primary 6, he would be highly respected by the community and might even be chosen as a leader of his community.

He then met my mother through the match making efforts of both their parents. My father was twenty years

old while my mother was only sixteen years old when they got married. It was very common to be married at a young age during that time. Girls were considered of marriageable age as young as fourteen years old. Before my mother got married, some of her friends were already mothers or mothers-to-be. According to our tradition, the groom has to pay for all related wedding expenses, which includes a small wedding banquet. My father used the savings that he had accumulated over the years from his teaching job to take care of those expenses. Before long, my mother gave birth to my eldest brother, Kaova, at the age of seventeen. Three years later, my second eldest brother, Kaeva, came along. I was born eighteen months after Kaeva. Due to some instability in Vinai Camp, many refugees, including my family, then migrated to Napho Camp. My sister Meiva and my brother, Souva were born in Napho camp before we moved back to Laos.

I still remember vividly that my brother Souva gave my mother a very hard time as he kept crying on the bus when we were moving back to Laos. Many refugees on the bus got quite agitated by his loud crying.

"Miss, please shut your baby up!" a lady shouted rudely from the rear of the bus. Usually, the Mienh ladies were mild-mannered and tolerant. Therefore, startled by the uncouthness of her language, I promptly turned to look for the source. Morbidly obese, the lady

occupied two-seats at the back of the bus. Her hair was messy, her face pork-marked and speckled with acne. Her expression was one of hostility and loathing. Even at that very young age, I felt angry that she had displayed a lack of compassion and sympathy towards a baby. I had the urge to walk over and slap her in the face. Deep inside my heart, I labeled her the most inconsiderate and insolent lady I had ever met in my life.

"Doesn't she know that it is not easy to take care of a baby?" I muttered furiously under my breath, staring at her repulsive round face. When nobody seemed to bother about her outcry, she just mumbled to herself.

In Napho Camp, my father was also a medic by training. So on the way to Laos, he was assigned the task of taking care of an old man who was very ill. The UN had asked him to perform this role as this old man had no one with him. All his relatives were in Laos waiting for him. On the bus, my father had to constantly attend to his needs, feeding him and even changing his clothes for him. On the way, he had diarrhea and soiled his pants on the bus, immediately filling the stale hot air inside with an unbearable stench. Frail and weak, the old man could do nothing but lie in his soiled pants and endure the complaints of the other passengers. Like any other kids and some adults on the bus, I pinched my nose and occasionally waved the pungent smell away from my nose.

"Saengva, get the old man out, please," a random voice rang out on the bus.

"He will kill all of us real soon."

"Please get him out. I am going to puke. Damn it! The smelliest shit ever."

All sorts of comments and nasty words flew all over in the fifty-passenger bus. I could see that my father was very angry and irritated as well but what could he do? The bus was moving and could not just stop anywhere. My father tried his best to ask them for their understanding. But no one seemed to share his sentiment. The bus was crowded with people and boxes and all sorts of things like stools, clothes and animal cages hung in every conceivable nook and cranny. All these things blocked the windows, preventing the air from flowing freely. To me, it was a blessing that no one had suffocated thus far.

Thankfully, when the bus rumbled to a stop at its designated rest point, everyone dashed to the toilets. The queue in front of the toilets snaked for about fifteen meters. My mother freshened my fussing brother up by wiping him down with a wet towel distributed to us on the bus. My father also had to clean the old man up and I could see that my father was furious at having been assigned this most unpleasant of tasks. However, he still washed and sanitized the old man thoroughly before getting him up onto the bus again.

The Mienh Way of Naming

~ ~ ~ ~ ~ * * * ~ ~ ~ ~ ~

In my culture, there is a standard way of naming children. If the firstborn is a son, he will be named Kao, followed by a second syllable. If the second child is also a son, he will be named Loh, followed by the same syllable as the first born—now known as the common syllable. Then, this is followed by San, Sou, Wu and so on. Therefore, my name is San. However, if there was a house guest at the time when a child was born, the child would be named Kae, followed by the common syllable. This second syllable of the name is guided by the father's name. For example, my father's name is Saengva, therefore, "va" is the common syllable

for his offspring. Since I am called Sanva, you may wonder how I would name my son in future. Well, I cannot name him Kaova as that will be in conflict with my brother's name. In the Mienh culture, every male child is given two names; one is a child's name and the other is an adult's name. My name as a child is Sanva and my adult name is Fu Jiu. Therefore, my first son will be named Kao Jiu.

For my father, his child's name is Lohseng. Then, he changed to Saengva after he attended the ceremonial rite to signify his entering adulthood. There is no age limit to this ceremony. Every Mienh man has to go through this once in his lifetime. As long as one passes through the ceremony, he can call himself the adult's name. By right, I should be called Fu Jiu when I attended the ceremony at the age of ten years old to signify my adulthood. But it was not convenient to change my records so my name still remains as Sanva till now.

As for the girls, the first daughter will be named Mei, followed by Nai, Fahm, Fei and so on in a respective order. Some boys and girls might be named Nging if they were very small in size at birth. This is one of the unisex names used that is guided by the circumstances when the child is born. Some families with many male children may name their latest male offspring a girl's name, in the hope that the next child will be a female.

Apart from the conventional way of naming, the Mienh people also name their babies based on what they see and feel. To me, this is a constant reminder of how our people remain close to nature, which our actions are highly connected to and guided by. Because of this, a lot of Mienh people end up having the same names. For example, there are many Mienh people with the same name as me.

Even for the surname, there are only 12 surnames in the Mienh culture. The most common ones would be Saechao, Saephan, Saelee and Saetern. Because of this limitation, it does not mean we are related even if we have the same surname. Historically, we might be related in one way or another. But over the years, this has gradually ceased to be true. Nevertheless, the Mienh people have a special way of tracing their kinship based on the spirits that they worship. If they worship the same spirits in the same way, they are somehow related. Then, they will start to find out about their ancestors and investigate further how they are related. For a family that has kept the family census record, it would be easier. Such records even capture the weather conditions, the cardinal direction the dead faces at the point of burial. All these serve as hints for them to trace their roots and to find their own relatives.

Beauty of the Nights

~ ~ ~ ~ ~ * * * ~ ~ ~ ~ ~

I remember having so much fun in Napho Camp when I was young. The other refugee kids and I played hide-and-seek, and everyone screamed very loudly when spotted by the seeker. Once everybody, except the last person, had been spotted, we all chanted and gave the last hider directions where the seeker was heading to. This was so that the last hider would be able to sneak up behind and pat the seeker's back without being first spotted by the seeker. If the last hider could do that, then all of us were safe and went back to being hiders again. The seeker would have to be a seeker for another round. If the last hider was unsuccessful in patting the

seeker's back, then the first person who was spotted by the seeker would be a seeker for the next round. We played this game almost every night but never got bored of it as it was simply so much fun. But hiding in a dark corner could be quite scary. The whole refugee camp was almost pitch-dark, with only dim candle light softly radiating from the quarters where all of us resided. That was why hide-and-seek could be quite scary sometimes although it was so joyful and fun to play.

On one of the nights when all of us, except the last person, had been spotted, we chanted, "Hoolay Hoo. Hoolay Hoo. Ghost is coming." This was to give the last person a signal that he was the only one left unspotted. We followed the seeker closely so as to distract him. Some of us knew where the last person was hiding but we intentionally distracted the seeker by repeating the same chant incessantly.

"Shut up!" the seeker shouted, irritated by the noise. His name was Kaohin.

We tried to divert the seeker's attention so that when the seeker's back was facing the last hider, some of us secretly signaled to the hider so that he could jump out to pat the seeker's back.

"Ouch!" exclaimed Kaohin. The force of the hider's pat propelled his scrawny frame forward, almost pushing him to the ground. He was probably more disheartened

at being outsmarted than reeling from any physical discomfort. I knew that feeling and empathized with Kaohin for I had been a seeker a handful of times too. But that was how the game was played.

Skinny and bony, Kaohin looked much like a stick that swayed with the wind whenever he walked. His eyes were so small that he had to force himself to open them bigger whenever he wanted to see some objects clearly. His face was sharp. Every time he laughed or smiled, his sharp chin would stretch out, making his side profile look like a crescent. But it was not as bad as a witch's face since his hair always looked neat and shiny. His complexion was smooth and flawless, which stirred the envy of every woman who saw him.

This game of hide-and-seek was never boring for me. We truly enjoyed one another's company. The night was filled with loud shrieks of laughter from happy and excited kids though the noise that we made sometimes could be quite annoying to the other refugees. We were so joyful, so carefree and had so much fun whenever we played this game.

The darkness of Napho Camp also gave it its splendor at night. When sunset came, the soiled and dusty main road was empty of vehicles. No dust. No filth. There was only the sound of crickets creating their beautiful and soothing melodies. To some, they were a

nuisance. But to my ears, it was precious music. Every time I listened to them singing, I felt that I was sitting in a concert hall, admiring them performing on the stage. Sometimes, I closed my eyes trying to imagine how the crickets would arrange themselves on the stage if they were singing in a real choir like the choir groups that I had seen in a Thai television program.

Coupled with this harmonious sound, the night sky sparkled with stars. We kids would sit in the middle of the road talking to one another with our eyes gazing into the sky. Sometimes, we would bring with us mattresses or banana leaves to lie on in the middle of the road, with our faces looking straight up into the starry sky. We could then talk about anything related to stars like why some stars were bigger than others and why some were clustered together but some were apart. We also counted the number of stars to see who would count the most even though the sky was blanketed with countless flashy and shiny ones. At that age, all we knew was just to savor the night, to savor the enjoyment of counting stars and to ask one another questions about them without expecting any answers.

"Look! That one is so big." I pointed my finger at a star. There were so many but surprisingly everyone knew which one I was referring to.

"No, that one is bigger. You see, it is so beautiful and it is surrounded by so many others," Kaohin spotted a bigger star. When Kaohin described how beautiful the whole sky was, his tone was melodiously in sync with the starry night.

After debating which star was bigger and more beautiful, another friend, Sankoy, randomly asked a question that all of us could not answer.

"Why do stars only appear in the night?"

This question stunned everyone. We chatted with one another on and on, coming up with some answers that we thought were logical even though we had no clue if our answers were right. Sankoy often asked weird questions that we did not understand. In fact, my father told me that Sankoy was a very clever person, but my other friends and I just did not know what he was talking about. Therefore, we did not appreciate his insights. Still, Kaohin, Sankoy and I always hung out together.

We continued lying down, closing and opening our eyes, hoping to see more stars appearing right in front of us when we opened our eyes. The sky was just so clear and starry. As we discussed and talked to one another, the night breeze caressed our faces. On the sides of the road, there were some wig trees planted along the entire stretch of that road. As the wind blew, it carried with it

the aroma of wig trees which wafted into our nostrils. At that time, wig trees were very expensive. My father told me that he had heard of some illegal logging of wig trees going on in some parts of Thailand. During summer, those wig trees would produce some sticky yellow glue on their stems and ants would crawl all over the trees. I often gathered the elastic glue and modeled it into various shapes. Oddly, it smelled really good.

The night was not only charmed with the appearance of the stars, but a night breeze and the fragrance of the trees. Down at the end of the road, there was a relatively big pond with many beautiful lotus flowers. Whenever we saw stars fall from the sky, we would pray for good luck and even cursed people that we did not like. Older people always said that if you made a wish at a time like this, you would get what you desired. After praying, we would excitedly run down to the pond. Upon standing at the bank of the pond, we turned left and right looking for any movement in the water as we believed that that was where the stars had just dropped into. Once, I remember that Sankoy threw a tiny pebble into the water, creating a wide spread of concentric circles.

When Kaohin saw the movement in the water, he quickly and excitedly shouted, "That is the star!"

I was giggling to myself as I fully knew what was going on. Souta, a friend of ours, had joined us that

night and we all were giggling, trying to suppress our laughter that threatened to burst out.

"Idiot! I am bluffing you," Sankoy, who had thrown the pebble into the water, laughed out loud.

Souta and I also laughed crazily along with him like crazy. But Kaohin was still a bit lost and he looked down with a sad face.

"How was I supposed to know that you made this up?" Kaohin said sadly.

I thought Kaohin was right. How could one know that it was Sankoy who had thrown a pebble into the water? All along, we always believed that the movement in the water was where the star had fallen. If I had not seen what Sankoy did, I would also have believed that it was the real shooting star that had created the circles.

While the three of us hung out very often, Souta only joined us occasionally. At that very young age, we did not really know what friendship was. Sometimes, we fought over trivial things. Sometimes, we kicked each other's buttocks and hurt each other as a result. But that never stopped us from doing it. During one of the fights, I scratched Sankoy's arms and ran away. I knew that I could not beat him but I just wanted to make sure that I got something out of it so I scratched him hard. I tripped over a dry piece of wood whilst running away and fell down with my right elbow sliding forward. Blood was

oozing out and when the wound eventually healed, it left a scar that remains till today. However, after the fights, we were still friends hanging out with one another as usual. Somehow, all these fights gave us something to talk about when we reminisced about the past. Ironically, they kept us bonded. Every time we talked about those old fights, we would laugh at ourselves, trying to boast about our own victories while putting the others down.

After we enjoyed ourselves from all the night activities, we went back to our respective quarters. When we left, there were still many young people walking along the road and some people were standing close to each other. The sight of couples chatting with each other was common. I remember a couple clearly as they were always at the same spot practically every night. The girl was leaning against the tree while the male was facing her, and they just talked and joked with each other. Sometimes, I saw them kissing each other. They kissed like a couple in one of the Thai TV series I was watching at that time.

This stretch of road had something unique about it. At night, it was a joyful place for people, including kids and young adults, to hang out at. During the day, it was a place for vehicles to pass through, stirring up dust all over the place. Even though it was dusty and noisy, many women, young and old, including my mother, would still

sit on their stools on the side of the road to sew their clothes and fabrics diligently. Some people would have a radio turned on beside them. At that time, many women were addicted to Thai series broadcasting on the radio. They just listened attentively while sewing. Compared to others, my mother was not so addicted to the radio but sometimes, she would sit beside her friends and listen with them too.

This is why in my memory this stretch of road is so vibrant and full of life in its own humble and unique way.

School Life

~ ~ ~ ~ ~ * * * ~ ~ ~ ~ ~

When I was young, I hated going to school. My father pushed me very hard to go to school. It was only after a month or two that I somehow found that school life was fun. Early in the morning, when it was still dark, my father would wake my older brothers and me up to study. While we studied under the flame of the candle light, my father would prepare loaves of bread spread with strawberry jam for us. Sometimes, a troop of ants would march on the bread but my father just brushed them off and served it to us. When my father was not paying attention, I would lick all of the strawberry jam on the bread and told my father that the

jam on my bread was not enough. He would then spread more for me.

Sometimes, my father would walk back from the kitchen with new candles to replace our existing candles if the wax had run down. Each of us had our own study desks. Those desks were small portable ones with pictures and the alphabets on top. Mine had the Thai alphabets while my brothers had the English alphabets.

After studying for a while, my brothers would go for their Chinese classes while I studied alone at home. I remember that sometimes my head would be nodding and my eyes closed. I did not dare to put my head on the desk as I was afraid that my father would spot me sleeping. However, I had never ever been scolded by my father for that. Instead of yelling at me for being asleep, my father would try to teach me and sometimes even gave me money as an incentive if I could correctly recite the standard multiplications.

"What have you learnt this morning?" my father would ask every morning.

"Do you know how to write this? Have you memorized the standard multiplications?" he pointed at some numbers and words on my notebooks, looking gently into my eyes.

Every time he asked me questions, I would keep quiet for a while. Sometimes, I really did not know how

to answer his questions. Sometimes, I knew but I was too sleepy to reply. After a momentary silence from my side, I would give my father a monosyllabic "Yes" or "No" kind of answer.

My father would hold my hand and slowly move it to form some alphabets or words that did not make sense to me at all. He patiently taught me, trying his very best to entertain me in whatever way he could. He knew that I loved listening to stories so he would sometimes tell me stories so that I would not fall asleep. I still remember vividly that one of the stories he told me was the "Xiang Miang". It was about a poor but witty man mocking and making fun of people who were of a higher social status than he was. I would always burst into laughter as it was indeed hilarious. Together with the jokes in the story, my father's expression was something that I could not stop laughing at. He was a marvelous story-teller as he really knew how to engage his audience.

Sometimes, I felt guilty that although my father had tried his utmost best to teach me, I just could not deliver what he expected of me. Learning was not my passion and interest at that time.

When the dawn broke with the sun's rays penetrating our humble abode, it signaled to me that it was time to go to school. My brothers and I, together with other kids from the refugee camp, started to make our way

to school. Along the way, laughter and noise would fill the air as we walked to our school. After about twenty minutes of walking, we would then reach the school. The medium of instruction used in school was Lao as all of the people in the camp were of Laotian origin. In fact, all of the teachers were refugees that had run away from the war in Laos just like us.

I was in primary 1 at that time and it was my first year in school. There was no kindergarten or nursery school in the camp. In fact, in the entire camp, there was only one school for all the children from primary 1 to primary 6. The school buildings were arranged in four parallel rows. Between them, there was a huge empty space where the students could play around during the recess. Though different levels were put in different buildings, the students from various levels always ran around and interacted with one another. The trees planted along the school fence gave us shade from the hot afternoon sun.

When our form teacher walked into the class, all the noise in the room immediately ceased. I can even now remember how she looked. She had shoulder-length hair and a rather tanned complexion. She wore her hair loose and every time she walked up and down the aisle, she would flick her head and her hair would bounce slightly. She had sharp features and a pair of big eyes. When she

looked at her students, her eyes would open wide, her irises focusing intensely on us. I was very intimidated by her and I reckon that the rest of the students felt the same way. Her voice was also very powerful. When she taught us the alphabets, she would hit the black board loudly with the rod as she read out loud. We then repeated each letter after her in unison.

Once she asked me to read one of the letters but I could not remember how to read it. Because of that, she asked me to stand in front of the class with a ruler in my mouth throughout the lesson as a form of punishment.

"Sanva, how do you read this letter?" she pointed her rod on the letter, looking at me from across the row.

"Ah . . . ah . . ." I stumbled over the letter, trying to recall but failing to produce any sensible sound with my mouth. My tongue had stiffened up, and I could not move it at all no matter how much I tried to. I could feel a wave of fear washing down my spine and my nerves tingling as I tried hard to find the right pronunciation.

"Ah . . . ah . . . is it 'Mo-Maew'?" I mustered all my courage to form a slight sound with my trembling lips.

"No! Did you practise reading at home?" she questioned, tapping her rod on the worn out black board very loudly and fiercely.

"Come out here and stand in front of the class throughout this period!"

However, I was not alone. Slowly, a few others later joined me in the line. Nevertheless, it was good that she did not ask us to step on thorny durian skin like the class next door had to. At that point in time, I did not experience a sense of embarrassment or fear at all. A classmate of mine was so embarrassed that she covered her face with a book when she walked out to stand with me. When the teacher asked her to put her book down, she immediately burst into tears.

Before the teacher dismissed the class, she would erase the writing on the black board, causing the traces of white chalk to fly all over the place. Some parts of the board were so rough that the writing could not be erased completely. Therefore, she had to erase them very hard. I could feel the chalk flying into my mouth and my face but could not do anything to remove it as I was not allowed to move at all. She then asked us to go back to our seats. When the bell rang, every student stood up and thanked her before she left the classroom. It was rude and unacceptable for students to leave the classroom before the teacher.

After the class, there were activities in the library waiting for us. I always waited for this as there were so many fun activities. Every time the bell signaled the end of lesson, I dashed to the library. Once outside the class room, all of us rushed towards the library like an

army going to war. As we ran, dust filled the air like a thick brown cloud hovering above our heads. In the library, sometimes we played games or were taught how to sing and dance. If we were lucky enough, there was free milk for us to drink. No matter what the activity that was planned for us, I always enjoyed myself, be it in the library playing games, singing songs or flipping through pages of books to look at pictures. Although I did not understand what they were, I was very engrossed and intrigued by them.

I went to the library so often that the librarian could remember my name. There was once the librarian greeted me, much to my surprise. Before I stepped into the library, she greeted me in her animated voice, "Good afternoon, Sanva."

I was momentarily shocked. I asked myself, "How could she know that it was me? She has not seen my face yet."

"Good afternoon, Sister Kamdee," I replied with astonishment as I walked into the library.

I still could not get over the lingering astonishment so I decided to ask Sister Kamdee, "How did you know that it was me when you had not seen my face yet?"

"Oh my little Sanva, the sound of your steps is enough for me to know that it is you. It is so unique."

"Even if you were walking from a very far distance, I could still detect that it was you. No one is as cute as my little boy," Sister Kamdee said vivaciously as she smiled at me, with her hands busy wrapping a book. I was flattered and stood there, grinning shyly to myself.

Sister Kamdee was always friendly. Every student loved interacting with her as she would offer her assistance without fail. Kaohin, Sankoy and I loved talking to her whenever we came to the library together. She would find us some very interesting books such as comics and cartoons. She sometimes taught us how to sing when the library was relatively quiet. Throughout my visits there, I only encountered Sister Kamdee scolding a group of students once. Those students were making a lot of noise and shouting vulgarities at one another. Sister Kamdee warned them a few times but they still talked very loudly and laughed as if the whole library belonged to them. Eventually, she decided to walk towards them with a rod in her hands.

"If you don't get out at the count of three, I will lay this down on your backs," Sister Kamdee shouted as loud as she could. But a naturally soft speaker like her could only do that much. Nevertheless, the students dashed off swiftly as if they were being chased by a ghost. A boy fell down as he tripped over the door step but he quickly got up and ran off.

During one of my visits to the library, I particularly remember one book as it really caught my attention. The whole book was full of pictures of different kinds of fish. As I flipped through the pages, I started to think of the pond at the end of the road in Napho Camp. Naughty and curious at that time, I tore out a few pages and hid them in my pockets. When the night came, I showed them to Kaohin and Sankoy. They asked where I had got them from and I just said I had picked them up from the road. They believed me unquestioningly. At that time, I did not feel any guilt at all. I simply enjoyed looking at the pictures even though I could not read the descriptions on the side of each picture.

Examinations

~ ~ ~ ~ ~ * * * ~ ~ ~ ~ ~

The school term had passed by quite fast. When the examinations were drawing near, my father forced me to study very hard but I felt that nothing was going into my head. When I asked him why he was pushing me much harder than my brothers, he just looked into my eyes and said that it was because my brothers were smarter and they could study by themselves. It was indeed true. I noticed that my brothers studied really hard. As for me, I was the opposite. When the examinations came, I did not feel any pressure at all. I was so relaxed as if it was like a normal school day.

"Bro, why do you have so many books to study?" I asked Kaeva as I compared the number of his books to mine.

"If I do not study hard, I will fail. I am not as lazy as you," he replied with a shade of contempt in his tone.

He did not even bother looking at me when he replied. "Did he even answer my question?" I wondered.

"But no matter how hard you study, you will still fail," I said somewhat mischievously.

"Go away! I need to concentrate. Don't disturb me," he added, chasing me away like he always did to the strayed dog that often came by our quarter.

I had not made any noise at all. I had only asked him a few questions and watched him study most of the time. However, I was not hurt by his remarks. I had gotten so used to his sarcasm that I took whatever he said in my stride. At that time, anything that was related to studies did not gain entry into my head at all. I did not care about what he said. I just sat there beside him as instructed by my father and pretended to flip through the pages.

Kaeva was the smartest kid in the family, but I could see that he was extremely nervous when revising for his exams. Uncle Saengfou and my father kept praising him for his good grades. He could draw very well too.

Sometimes, I asked him to draw or do my homework for me, but most of the time I got no favors from him.

One interesting incident happened on the day of an examination. Kaeva wet and dirtied his pants in the examination hall. After the paper, the school informed my parents about it and my father and I went to clean up for him. After the incident, Kaeva was simply too humiliated to go to school to clean up. His chair looked like there was an opaque circle stuck on it as a result of his urine. I knew some of his friends, and they were all making fun of him. However, my father did not scold Kaeva for what had happened but instead took it as a joke. We all laughed at the incident every time someone brought it up. It had become a regular "routine". He wet his pants quite often whenever he was stressed.

My parents gave Kaeva the private part of crabs to eat as the Mienh people believed that eating it would serve as a cure to stop someone from wetting his pants. They sourced for all sorts of crabs but none of them seemed to prevent Kaeva from wetting his pants. After a while, my parents just gave up and did not quite believe in the so-called traditional way of curing such a case.

Kaeva and I were born one and the half years apart. When I was born, he was immediately deprived of breast milk. I took it all from him. My mother had to carry him to the health center to receive vitamins and powdered

milk almost every day. My mother often told me that both of us were crying equally loudly so she had a very hard time taking care of us. However, I did not cry as frequently as my brother did. Possibly due to the lack of breast milk, Kaeva was very skinny and pale. He often fell ill and cried until his throat dried up. Tears masked his face and he looked as if he was choking. Many a time, my father quickly came over and fed him with water as my mother stood mutely in shock. We believe it is because of this lack of breast milk that my brother is smaller and shorter than I am.

Nevertheless, my brother was much smarter than I was. When the examinations results were released, both of my brothers passed their examinations. Kaeva passed with a high distinction and Kaova just passed. As for me, I failed the exam terribly. However, I did not feel any tint of sadness or embarrassment at all. Because of my bad results, I was retained in primary 1 and had to face my teacher for one more year. Although I did not feel anything for myself, I could feel that my father was very sad and angry with me. When I sat down beside him at the kitchen, he asked me a series of questions about why I had failed my examinations but I just kept quiet and looked down at the ground. I really could not give him an answer no matter how hard I tried. Mixed thoughts just ran through my head like an electric current.

"Why did you fail?" my father questioned me repeatedly as a policeman would interrogate a suspect.

I offered him no answers. Sitting down quietly on a chair with my head lowered, I tried to form words but was totally mute.

"Do you want me to give an answer?" he bellowed. That rhetorical question hit me hard.

"Look at me!"

As I turned up and stole a quick glance at his face, I realized that I had never seen him so fierce before. His face was red as he clenched his jaw. I wanted to cry but I was too scared to let a single tear seep from my already swollen eyes. I was traumatized by his anger.

All of a sudden, a rod landed smack against my back. It was extremely painful. I could feel my back arch forward from the excruciating pain. I started crying very loudly. I was just sitting still, crying and trembling as the rod came down on my back again and again. With every stroke, I felt like my back was breaking apart. My father was yelling and hitting me at the same time. I was numbed by the pain and so shocked that I could not get up to run away. The fear of being chased after by my father was gripping my whole body, locking my limbs in place.

After a while, my mother ran into the kitchen to intervene. She hugged me, shielding me from my father's rod.

My mother shouted, "Enough! Enough!" and carried me away.

"Are you going to murder your own son?" she cried out while trying to console me.

At that moment, all I could feel was the severe pain on my back. However, I did not hate my father or was angry at him for hitting me. I just sat beside my mother and cried silently throughout the afternoon. I knew that I deserved the punishment. Of all the days in my life, I remember that day the clearest. I was totally lost and shocked by my father's anger. I had never been hit by him before until that day, the very day I failed my examinations. He must have been very disappointed in me for he had put so much effort in ensuring that I would do well in the examinations.

English Classes

~ ~ ~ ~ ~ * * * ~ ~ ~ ~ ~

Throughout my summer holiday, my father did not ask me to study at all and I did not bother to touch any books. My brothers were sent for English classes in the early evenings. For the first time in my life, I actually felt like studying English when I saw my brothers studying and learning how to pronounce words. After the caning, I was very quiet and distant from my father for about a week. I kept quiet every time I saw him, as if he was a stranger to me.

"Maybe he also does not want to talk to me," I thought to myself.

We just walked past each other. With a father's authority, he would order me to do some household duties and help him out with some stuff. That constituted all our interactions. His tone became colder when he talked to me. I was still too afraid to initiate any conversations with him so most of the time, he would initiate them. Our close ties seemed to have been broken by the rod that fell down on my back.

It took me quite a while to resolve this issue. It was the day I realized I wanted to study English that I decided to approach my father to ask his permission to learn English. It took a lot of courage. I was very afraid that he would scold me. To my amazement, he turned to me and said gently that I was too young to study English. He did not scold me at all. His tone was perfectly normal and contained no bitterness in it.

"I think you have to brush up your Lao language first," he suggested.

"If you are very good at your Lao language, I will send you to as many classes as you want."

I thought he was right. I needed to be good at Lao first.

However, I questioned him and added, "Kaeva is only one and a half years older than me but he can study English."

Deep down in my heart, I knew that Kaeva was way smarter than I was. He could read and write everything under the sun while I was the total opposite. Comparing both of my brothers with me would be an insult to them. However, I thought that my father should still let me try. In my head, I imagined how excited I would be if I could attend English class with my brother. The thought of learning a foreign language simply intrigued me.

I thought my father did not want to hurt me by comparing my studying abilities with Kaeva's so he just insisted with a fatherly tone that, "San, you are still too young to learn a new language."

On the other hand, I guess it was quite fair if my father did compare our academic differences. Kaeva went to school early due to his enthusiasm and genuine interest in studying. When I was in primary 1, he was in primary 3 together with my brother Kaova. After many rounds of failed attempts, I decided to stop asking my father. No matter how hard I tried to convince him, he could not see or feel my genuine passion for English. To him, I was still weak at Lao so I had to brush up on my Lao first before I could do anything else.

One day, I stealthily followed my brothers to an English class but halfway there, they both disappeared. They knew that I had followed them and they just did not want me to be with them. I did not know where

the class was so I went back home, feeling aggrieved. But on the way home, I got lost. I had blindly followed my brothers without any clear sense of direction. Most of the time, I just followed my friends or asked around for directions whenever I needed to go somewhere not familiar to me.

I believed that the act of following my brothers to their English class alone was enough to prove that I was genuinely interested in learning. However, this genuine interest was too subtle for my father. Although I did not manage to convince him, I still hoped that one day I could become smart enough for him to send me to English classes like my brothers.

Old Lady

~ ~ ~ ~ ~ * * * ~ ~ ~ ~ ~

Throughout that summer, my brothers went to their English classes. Every time I followed them, they would run away from me and I just could not catch up with them for I did not run as fast as they did. My father said that if I wanted to follow my brothers to their class, I needed to master the entire Lao alphabets and memorize all the standard multiplications first. I was very excited at the promise he had made to me. "This is a good deal," I told myself.

I would sit beside my father in his hospital and diligently study with him. My father had multiple jobs. In Vinai Camp, he was a teacher. When we moved to

Napho Camp, he became a trained medic for the UN as well as a translator for people who wanted to emigrate. That was why I said my father was a brilliant man.

The hospital was kind of small but the garden surrounding it was beautiful. It was just a single-floor bungalow with a red roof. There were less than five rooms inside the hospital. However, it looked new and well-maintained. Its entire surrounding was very serene and clean, with trees and flowers planted along the sides of the road, leading up to the building.

Every time I went to the hospital with my father, I noticed an old lady strolling slowly up and down the garden. Sometimes, I told myself even a turtle could crawl faster than she could. This old lady had a hunched back and she walked with her hands crossed behind her back. Her hair was pure grey and tied loosely in a messy bun on top of her head. To say that it looked like a bird's nest would be a good description. Her face was freckled with many liver spots and lined with age. She always seemed to be dressed in the same set of clothes, a purple shirt paired with a long black skirt. Sometimes along the way, she stopped and smelled the flowers on the side-walk. Even on a sunny day, she would still walk up and down. To try to get her attention one day, I wheeled a tire with a rod along the side-walk the way I played with my friends in the camp. I turned to look at her

frequently but she did not glance my way. She did not care about my presence at all. After a while, I got tired of it. Out of curiosity, I asked my father why this lady was always there.

"Dad, does she have a family?" I asked my father.

"Why are you so interested in her, my boy?" my father asked me. However, I did not think he wanted an answer from me. I got the hint from him that I should mind my own business and not ask unnecessary questions. Nevertheless, my curiosity was still yearning for an answer.

"Of course, she has a family. However, she is too old to remember anyone. She cannot even remember her own children," my father replied as he was scribbling something down in his notebook.

"Her children tried to take care of her but they have all given up after a while as she has created so many problems for them."

"However, we should not neglect her. She became like this right after her husband passed away." My father patted my head as he said this to me.

"One thing you have to learn in life is not to abandon your parents, your loved ones and those who are good to you. This is very important," he added.

My father paused. I was waiting for him to tell me more about this old lady but he stopped his narration

and went to check on a patient. However, I found out from my mother that this old lady's husband died while escaping from Laos to Thailand during the war. Her husband joined the Mienh troops to fight against the Pathet Lao army. He was shot dead and his body was never found. All that this old lady could remember was how to walk back and forth from the hospital to her living quarter. She had been in a state of senility for quite a number of years already. As I looked at her closely one day, I could see that her eyes were filled with sadness. That pair of eyes always appeared watery to me but never once had I seen tears flowing from them.

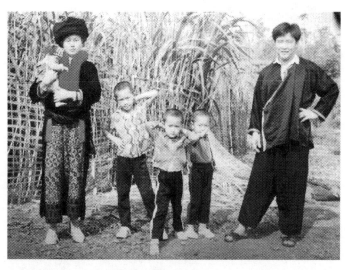

Left to right: My mother, my sister Meiva, my first brother Kaova, my second brother Kaeva, me and my father in Vinai Camp, Thailand, 1991

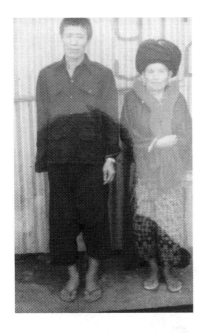

My grandfather and
my grandmother

My mother, my
father and my first
brother Kaova in
Nam Yao camp,
Thailand, 1984

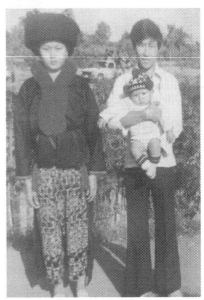

Houses in Vinai
camp, Thailand.

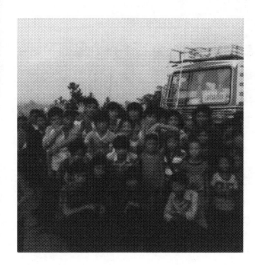

Atmosphere at
the last day of
the camp

Refugees
carrying boxes
to the bus

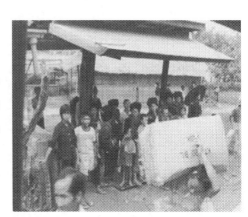

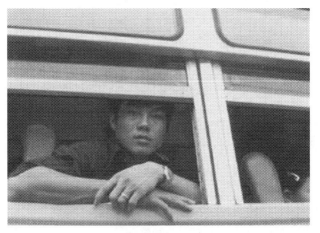

My uncle on the bus leaving for another camp
to attend an interview to go to the US

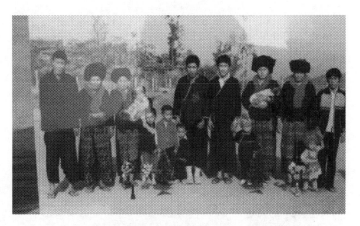

From left to right: My grandfather, my grandmother, my aunt (uncle's Saengfou's wife), Uncle Saengfou's children, Uncle Saengfou, my father, my mother, my first brother Kaova, my aunt (my dad's sister), my aunt's daughter and my uncle.

My mother (in blue shirt) with my first brother
Kaova attending Iu-Mienh language class

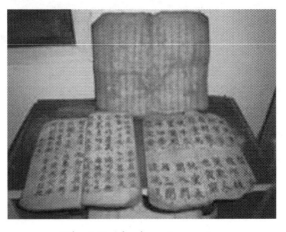

The Mienh chanting script

Operation

~ ~ ~ ~ ~ * * * ~ ~ ~ ~ ~

Once while I was studying inside my father's office, a nurse knocked at the door and anxiously informed my father that a patient' leg was bleeding profusely. Without delay, my father got up from his chair and followed the nurse to the emergency room. There were only two beds in the room surrounded by shoulder-height wooden walls. I could jump up and peep inside. My father and another nurse washed the patient's leg with some light blue solution that looked like an antiseptic that he had shown me at home while the nurse prepared the bandages. After washing the blood away, the nurse then started stitching the cut on the leg

with a big needle and white thread while my father held on to the patient's leg.

"Aargh . . . Aargh!" the patient screamed his lungs out.

"Calm down, it is going to be alright," my father soothed him.

However, the patient still jerked his leg every time the needle penetrated the wounded area. He shut his eyes very tightly. I could see him quietly writhing with pain.

"Yes. That's the way. We are almost done," my father encouraged him while the nurse focused on her sewing.

As I watched my father and the nurse performing the operation, my heart was beating faster than usual. Somehow, I just wanted to jump over the wall and be there with them. From that moment, I developed an aspiration to be a doctor when I grew up. Everything about my father was so admirable to me. The white coat, the mask and the gloves that he was wearing made me want to wear them too. However, I wondered how my father could breathe when he covered his mouth with the mask. I remember when I had covered my mouth and nose from the pungent smell of Kaohin's fart, I had almost suffocated.

The patient was a young adult, probably in his 20s. I thought to myself that if he was my age, he would

scream like a mad dog. His father and his wife were also outside with me watching the whole process. I could feel my nerves tingle every time the nurse gingerly pulled up the thread and inserted the hypodermic needle into the patient's leg. The wife occasionally covered her face with both hands, and I could see her forehead creasing into lines as the nurse sewed a stitch. The father, on the other hand, was a relatively calm man. He did not really show any signs of worry at all. In fact, he just crossed his hands together while projecting a serious expression. I was standing there watching everyone and wondering how agonizing the procedure was.

When the stitches were done, the nurse handed over the bandage to my father and he wrapped it around the patient's leg neatly. The patient wanted to get up to take a look at his wound but the nurse gently pushed him back onto the sick bed, asking him to lie flat for a while. Had I been the patient, I would have been curious too.

"Hoo . . . finally," my father and the nurse sighed with relief.

The whole operation took about an hour. When my father was out of the emergency room, I told him that I wanted to be like him. He patted my head and asked me to go back into his office while he attended to other patients. We exchanged smiles and I went back to his office. Instead of focusing on my work, my mind was

wandering wildly. I pictured myself wearing the doctor's outfit like the one I had seen in a Thai drama series. The doctor had a note pad in his hand. He scribbled something on it as he walked and talked to his nurses at the same time. After he was done, he handed over the note pad to one of the nurses, and everyone went into the operation room. As they pushed through the door, they entered a dimly lit room. Everyone started to slip on their gloves and put on their clinical masks. The nurses were handing the doctor the surgical tools. Everyone was so quiet and their eyes were fixed on the wound. Beads of perspiration formed on the doctor's forehead. As I imagined this, I smiled to myself. Every thought that passed through my mind further reinforced my aspirations of being a doctor.

When it was time to go home, I still saw the old lady walking up and down along the side-walk. This time she was walking all the way down to the immigration check-point behind the hospital. She was still wearing the same clothes.

The Immigration Check-Point

~ ~ ~ ~ ~ * * * ~ ~ ~ ~ ~

This immigration check-point was to control the flow of people going in and out of Napho Camp. Surrounding the borders were tall walls of barbed wire. To enhance the security, there were also shards of broken glass on the ground of the other side of the wall. However, the very sight of the sharp barbs alone was enough to deter people from crossing over. There was a small guardhouse beside the gate. The smartly uniformed Thai officers could often be seen walking around and chatting with their friends at the immigration check-point. However, not all of them were

friendly. In fact, many of them always wore serious looks on their faces.

Since this was the only gate to get out of Napho Camp, many refugees would try very hard to break through. In fact, there was one incident when many refugees, including the Hmong, the Mienh, the Khmu and the refugees of other ethnicities, gathered together on one of the nights to break through the gate. Many of the refugees carried torch flames and roared fiercely and loudly. I could not gather what they were shouting. We kids were observing from a distance. We wanted to get near the action but somehow we were afraid. A lengthy negotiation went on between the refugees and the Thai police officers. All I knew was the refugees just wanted to break down the fence so that they could go in and out of the camp freely. Some fuming refugees threw the torches onto the ground and some took off their shirts and tied them around their fists. The Thai police officers were pointing their guns into the sky with their fingers on the triggers, ready to shoot. Before the situation got worse, a few police cars came over from the other side of the fence with their sirens screaming. When the police stopped their car engines, they walked out with guns in their hands. The refugees and the police continued to negotiate for a while before the crowd started to disperse.

Despite all the chaos and bad perception that we had of the Thai police officers, I personally found some of them rather friendly and pleasant to talk to. My father asked me not to go near them but somehow his warnings did not inhibit me in the least. Their uniforms attracted me a lot. Maybe that was the thing that drew me to them.

"Hello, sir," I greeted one of the officers when I saw him standing outside the hospital looking towards the immigration check-point gate.

The hospital was very close to the check-point. On that day, Kaohin and I had gone to the hospital to visit my father. Though I told myself that I was not afraid of approaching the Thai officer, I still had some fear. If I had been there alone on that day, I would not have dared to even take a quick glance at the Thai officer.

"Hi, boys," the officer greeted us with a big smile on his face. I was momentarily surprised by his grin.

"Why do you have to wear that uniform?" Kaohin asked out of curiosity and innocence.

"Oh . . . do you want to wear it?" the officer pinched his uniform as if he was going to offer it to us.

"No. We are just curious about it," I replied immediately.

"Oh . . . you can become like me one day," the officer said and smiled. He asked me and Kaohin why we were at the hospital. I told him that I was here to visit my

father. I could feel that the Thai police officer was pretty surprised when he found out that my father worked in the hospital. After talking animatedly for a while, the officer turned to look around and walked away with a smile on his face. I wanted to ask him how I could become like him but he walked away so fast that I could not utter my words on time.

I remember that I only passed by this immigration check-point to go to the town when there was a festival. Our parents would bring us there in a pick-up truck from the bus station right behind the immigration check-point.

After a long tiring journey at the back of the pick-up truck, we would be welcomed by beautiful lights at the festival. My mother would let us try the merry-go-round, Ferris wheel and other rides. It was so exciting. The adults would play games like throwing balls into a stacked pyramid of empty condensed milk cans, throwing arrows onto boards and many other games.

"Kao, do you see mom there?" I pointed at my mother when we were at the top of the Ferris wheel.

"Where is she?" Kaova asked me.

"There she is. She is holding on to Meiva looking up at us," Kaeva directed Kaova.

"I see her. She looks so small and petite. All the people look so small. Dad is not there, right?" Kaova asked.

"There he is. He is just behind mom but he is watching his friends playing the spinning game," Kaeva directed both our attentions to the spot.

Everything indeed looked very small but luckily I was not scared of heights at all. In fact, I felt like I was a bird flying high in the sky as the wheel spun slowly. The movement of it scared Kaova a little bit but not me. People were walking around in different directions on the ground. As I looked down to observe, I could see smoke from the food section coiling up to the starry sky.

When the wheel came near the ground, the three of us shouted, "Hello, mom!"

We did not see our father as he was blocked by our mother. But when he heard the greeting, he too quickly turned to look at us and shouted energetically, "Hello!"

We had so much fun. After riding the Ferris wheel, we went to try out the merry-go-round. I had already targeted the one I wanted to ride on. When the ride stopped, I quickly showed my ticket and ran to the seat that I was eyeing. When the merry-go-round started to turn, I intentionally jerked back and forth, following the rhythm of the music. Kaova and Kaeva were behind me. However, for some reason, I was a bit scared to turn back to look at them. As I looked at the gantry, a queue had already started to form for the next round.

After all these fun activities, my parents brought us to try some food. They were mainly grilled food on sticks. There were barbequed squid, grilled chicken and some fish balls. We enjoyed ourselves so much.

When it was time to go back home, everyone was so tired and I remember nodding off drowsily the way back home.

Sustenance

~ ~ ~ ~ ~ * * * ~ ~ ~ ~ ~

In Napho Camp, there was a constant supply of water and food provided by some organizations. Early in the morning, we would push our trolleys containing six gallons of twenty-five liter bottles to the water tank site and queue up for water. In all the years we were at the camp, no matter how early we arrived, we were never the first ones there. By the time we were there at about 5:30 a.m., there were already ten other trolleys in front of ours. As the dawn broke, the queue got longer and longer. While waiting, I would climb up to get flowers from a tree standing elegantly beside the big metallic water tank. It looked like a hibiscus tree. We

kids used the filaments of the flowers to play a game. We hooked the filaments of the two flowers and then pulled on the count of three to see whose filaments would fall off first. This was how my brothers and I entertained ourselves while waiting for our turn to fill our bottles. Sometimes if our grandfather came with us, we would stand beside the tree and play until our grandfather finished filling up all the bottles. Then, we pushed the trolley back. Sometimes, the last few households did not get any water as it had run out first. This was why we had to come early in the morning to queue up. Sometimes, if water had run out, refugees would come early in the evening to queue again as there were two rounds every day. In the evening, the road was damp and muddy because as we pushed the trolley on the rough and uneven ground, the water slopped and sloshed out of the receptacles along the way. I suppose the ground was muddy in the morning as well but it was too dark to notice. Sometimes, some people would quarrel over the water and sometimes this escalated into fighting.

On weekends, staples such as rice, meat and vegetables were given out to each household. The amount given out was according to the numbers in the family. Again, we had to queue up for the food but it was not as crowded as the queue for water. This was because there was ample food for every household. The officers

were distributing the rations and checking off the names of each family upon receiving their share of the rations. Sometimes, however, the vegetables were squashed or were not fresh and had many holes on their leaves as if they had been eaten by caterpillars. Some fruits were rotten and could not be eaten at all. Sometimes, the rice was also yellow, damp and could be broken into half easily. Nevertheless, we still ate them. Most of the time, there was excess food and we would throw them away if my grandfather did not use them to feed his chickens.

My father told me that we always ate the same kind of low quality food because of corruption. The UN would normally give enough money to the Thai officers to buy us good food but they would pocket a portion of it for their own use. This was the same in every refugee camp that my father had been to. He worked as a translator so he had been told this by some UN officers. The UN had been trying to curb this problem but to no avail. That was why the refugees were given bad food all the time. When my father told me this, I was very angry. The next time I went to queue up for the food I paid more attention on the officers' attitude and the vegetables, rice and meat in front of me. I did not ask my father but I guess this was the same reason why sometimes there was a shortage of water.

However, the refugees did not solely rely on the help from the Thai government or the UN organization for food. They also planted their own vegetables and raised their own domestic animals to supplement their rations. There was a big piece of land on the other side of the pond separating the refugee camp's residential area and a farm. It was on this piece of land that we grew vegetables. It was very convenient and accessible as water could be fetched from the pond just behind the vegetable plots. Almost every household had a small piece of land to grow vegetables. All the vegetables were normally the same: lettuce, lemon grass and a few others.

Ghostly Encounter

~ ~ ~ ~ ~ * * * ~ ~ ~ ~ ~

Beside the vegetable farms, there was a row of toilets belonging to different quarters. Sometimes, each quarter had more than one family. But each quarter was only given one toilet and some quarters with small number of family members shared the toilet. For example, Uncle Saengfou's family and my family lived together in the same quarter but we were given only one toilet. We were only separated by the rooms in which we stayed. There were three rooms and my grandfather took the smaller room. Everything else like the kitchen and common spaces were shared. The quarters had all the basic facilities that a family would need.

It was in the toilet that Kaohin and I first encountered something strange. At night, that side of the road was totally dark. If one wanted to go to the toilet, he needed to bring along a torch light and carry with him his own water from the quarter. Naughty as we were, we played hide-and-seek on that side of the road one night despite having been warned by our parents not to be there at night. Kaohin and I hid inside the toilet. It was so dark that we could not see each other. We could only feel each other's presence by squatting beside each other. After hiding for a while, we heard a sound of someone flushing the toilet in the next compartment, signaling the end of his "business". However, there was no sound of the door latch opening and in the following moments, silence completely engulfed the whole area.

"San, do you feel anything strange?" Kaohin whispered into my ear and huddled closer to me.

I nodded as I was too frightened to speak. The eerie silence was followed by the sound of crickets, which slowly started to roar in my ears. This was the first time that I found cricket noises so unpleasant to listen to. In fact, the very sound of them escalated the fear in me as the volume increased gradually into a crescendo.

"San, do you feel anything?" Kaohin whispered one more time when he did not hear my response.

"Yes, I do. Is that a ghost or something?" I softly and shakily whispered back into Kaohin's ear.

Both of us squatted very close to each other and I could feel our shoulders pressing against each other very hard. Then, suddenly, we jumped in terror when someone began pounding hysterically on our door. Our horror increased when the latch on our door lifted and the door swung open to reveal no one outside! I wanted to scream out loud but could not find the strength to project my voice. Kaohin pulled my hand and the both of us just shot up and ran for our lives out of the toilet, leaving the door swinging behind us. We did not care to look at what was behind us. As I was running, I could feel someone following me. His steps seemed to storm louder than mine. Kaohin was in front of me so it could not be him. However, I did not turn back at all as I had only one goal in my mind: to dash to the safety of our quarters as fast as possible.

The next day we told our story to the rest of our friends and laughed at ourselves. I was not a good story teller so I let Kaohin narrate the whole story instead. His expression morphed with the flow of the story and it was very funny to see him twisting and turning as he told the story. When he was narrating the part about someone knocking at the door, there was a deafening silence and I could practically hear the rhythm of everyone's breathing.

I could see a friend beside me pressing against his chest as if trying to keep his trembling heart from exploding out of fear. There were times that Kaohin exaggerated but the gist of the story was there. After that incident, we still did not stop playing the game and instead we challenged one another to hide in that area more often despite the stern admonishments of our parents.

The River

~ ~ ~ ~ ~ * * * ~ ~ ~ ~ ~

Beside the pond at the end of the road near my quarter, there was another big river about a thirty-minute walk from the living quarters. Many people would go there to fish and swim. Sometimes, we would bring home a few kilograms of fish and snail. The water was clear and as such it was very easy to spot snails hiding in the mud. This river was great for many activities. On a hot and sunny day, it was a perfect place to swim in. On the other side of the river, there was a large patch of farmland. Water supply for the farm came conveniently from the river. I witnessed the whole production cycle of farming starting from the planting of the crops in April

to harvesting in November. From April to June, the whole field was green. From September to November, the whole field would slowly turn into golden yellow, with rice stalks swaying gently in sync with the rhythm of the wind.

Before the water in the farm was drained off for harvesting, we would go there to source for fish and other edible water insects. Fish from the farm had a thicker texture and was more palatable than fish from the river. We went there in the early afternoon and left in the evening with our bodies splashed with mud. Before we headed back home, we would wash and clean ourselves up in the cool river. The sun's rays would shine on the river, making the whole place so beautiful. I felt like we were bathing and swimming in a pool of gold.

There was a bridge connecting the two sides of the banks so I often crossed over and stood at the other end of the bridge and started shouting across the river as loudly as possible. Many people believed that if you shouted on high ground, the wind would blow towards you, especially on a sunny day. Strangely, it really worked!

"Let's compete who can shout the loudest," Souta suggested.

"Sure!" Kaohin chimed in.

Kaohin started off first. After a while, the wind blew all over the field. Then it was my turn, but the wind that

followed was not as strong as when Kaohin did it. When Souta shouted, there was strong wind blowing from every direction. It was truly interesting to see how we could dictate nature with this simple command. After I had shouted in a certain way, the wind would start to caress my face. That was why I enjoyed doing the same thing whenever I came to this river.

It was also on the mountain beside this river that young adults wooed one another through the exchange of Mienh traditional songs. Couples would sing against each other. It was like a form of vocal sparring. The lyrics of the songs were created spontaneously, and the whole process was impromptu. Nevertheless, every single word contained so much meaning. This would usually happen in the late afternoon when people took a break to relax and rejuvenate themselves after a strenuous day in the farms. Such sessions were always enormously entertaining.

Actually, kids like my friends and I were banned from coming to this place. Our parents were afraid that we would drown in the river. There was one case of a boy who drowned in the river and his body was never found. The current of the river was very strong all year round. Sometimes, my parents were reluctant to allow me to come to this place unless I came with an adult. Thus we kids would secretly come here to swim without

letting our parents know. Despite going there several times, I still could not swim properly. If my grandfather knew that I was there, he would come after me with a rod in his hand. When he yelled, everyone would be very frightened of him. My friends and I would run away from him as fast as we could whenever he appeared.

Theft

~ ~ ~ ~ ~ * * * ~ ~ ~ ~ ~

On and off, some merchants would drive their pick-up trucks into Napho Camp. The pick-up trucks were normally filled with all sorts of snacks and candies. Everyone, both old and young, would get very excited whenever one came to our camp. Before the pick-up truck stopped its engine and parked, people would already have formed a line. Some had money in their hands and knew what they wanted to buy. It was often incredibly noisy. The merchants often gave the refugees discounts for bulk purchases. Because of that, some refugees started to plan ahead and pool their

orders to get discounts. Once they got the items, they would later split the purchase.

My mother often joined the queue too. She knew what her kids and husband loved. She always bought our favorite sugar-coated crackers shaped like DNA strands for us. Sometimes, my mom and my aunt (my father's sister) would buy in bulk and share. Everyone in the camp seemed to like it as it always ran out faster than any other items. It was delicious. I remember that I always licked my fingers after consuming it as the sugar often melted on my fingers.

On one of those days, the merchant parked his pick-up truck near the river when he went to get something from his friends in the camp. He asked the kids there to look after the pick-up truck for him and when he returned, he would give us some money. We agreed to it. However, as soon as he was gone, Kaohin, my brothers, some other kids and I started to strategize how to steal the snacks loaded behind the pick-up truck. I could not remember why everyone suddenly had the same idea of stealing. Kaova immediately took on the leadership role.

"You and you, go to the junction so that when the merchant returns, you can run over to signal to us," Kaova told his friends.

"You and you, once we pass the snacks to you, hide them at the corner near the well." Kaohin and I agreed to do it.

As soon as our roles were assigned, we quickly opened up the tarpaulin flap behind the pick-up truck. Kaova and a few of his friends started to pull out some snacks and handed them to us. Kaohin and I ran as fast as we could to hide the snacks. We did this for a few rounds before Kaova's friends signaled to us that the merchant was walking back to his pick-up truck. I could feel my body shuddering when the merchant returned. Instead of putting everything back nicely and escaping from the place, we waited there pretending nothing had happened. He came over to thank us and gave us 1 Baht each. Soon after the merchant left, we ran to the well nearby and split the snacks among us. I could not remember the exact number of people but there were roughly eight of us. We promised not to tell anyone this.

That was the first time that I felt I was a thief. However, I did not feel any guilt at all at that point in time. In fact, Kaohin and I talked about it a lot when no one was around. We recalled the situation and laughed merrily. If my parents had found out, I would have been caned. But everything went smoothly and no one, except the ones involved in the theft, knew about it. My grandfather was one who could not tolerate this kind of

behavior. Once I saw him caning Uncle Saengfou's son for stealing his money. With only one hand, he could still have so much strength when it came to caning his grandchildren. I had never been caned seriously by him before but when I saw him caning my uncle's son, my grandfather's face was blazing with anger and madness. He clenched his teeth very forcefully as he swung the rod hard against the buttock of my uncle's son. I reckon that it must have been extremely painful.

Opium

~ ~ ~ ~ ~ * * * ~ ~ ~ ~ ~

Besides war stories, my grandfather also talked about his life as an opium dealer and grower. He said when he was in Laos and Vinai Camp, opium business was one of the most profitable businesses. Many people did not know how to grow good opium but my grandfather did. As such, he made quite a handsome income after each harvest season. He used this income to support the family and send my father to extra Chinese and English classes.

In Napho Camp, there were quite a number of households with family members smoking opium. My friend's parents smoked opium so every time I went to

his house, I would see his parents smoking opium on their bed in the dim light. The whole aura of the room looked very gloomy and smoky. My friend's parents usually lay on their sides. Right in front of their faces were two gasoline lamps that were used to melt the opium. Issuing from their mouths was a long tube from the lamps, through which they inhaled the opium. One hand was used to hold the tube while the other arranged the opium on the end of the pipe. They used a little metallic stick to stuff the opium into the pipe. They looked so peaceful, enjoying every minute of their time.

When I first went to my friend's house, I could not stand the smell of the opium at all. However, as I visited him in his house more often, I slowly got used to the smell. It was indeed addictive as every time I went to his house, I would first peep into his parents' dark and cloudy bedroom lit with only the two gasoline lamps. I visited my friend at his house so regularly that I could even recognize the smell; it had its own unique flavor. As time passed, to say that the smell of it was as good as a perfume would not be an overstatement.

"Hey boy, do you want to try?" my friend's father offered me when I was watching them smoke one day.

"No!" I covered my mouth and went outside to wait for my friend instead.

My parents kept warning Kaova, Kaeva and me not to get near opium. They said it was bad, but at that time I did not know why it was. If it was so bad, why did many people still smoke it?

But I knew that smoking opium was actually illegal. Policemen would patrol the camp once in a while, especially on weekends, to catch opium smokers. Whenever policemen came, people in the camp would signal to one another in the Mienh dialect as the police were the Thai officers who could not understand our dialect. When the police came, opium smokers quickly kept all their opium paraphernalia. They would hide all these as fast as they could, making sure that they left no trace of opium behind at all. My friend's parents hid all the tools and opium in a hole in the ground that they purposely and strategically dug out to handle this kind of situations. After clearing everything, they would spray something around the house to get rid of the stench but I could not figure out whether the scent could really mask the strong smell of opium; I could still smell it. I used to ask my friend's father and he said the kind of scent that he used was very strong so he asked me not to worry about it.

On one of the spot checks, I remember a man was caught. His hands were cuffed together and the police dragged him along with them. As they were walking past

the blocks, other refugees encouraged him not to worry and said that he would be fine. One thing about the refugees was that they were very cooperative and helpful when it came to these kinds of matters. What the refugees said was true. The sentence was not that harsh. Normally, an opium smoker caught would be jailed for only two to three weeks. There was no rehabilitation center or anything like that to encourage people to quit smoking opium. They would not jail opium smokers for long as I guess it was both a financial and physical burden for the Thai authorities to imprison them. I guess it would even be better for the family as they had one less member to feed.

Despite all the bad effects of opium the officers would have us believe, it had its good points. When I was stung by a catfish, my index finger bled profusely. My grandfather quickly applied opium around the swollen area, as he said the opium helped to staunch blood flow. He also told me that it eased swellings and curbed pain. Indeed, after a few days, I did not see any trace of red swelling at all. There was one time when my friend's thumb was stung by a catfish and it was swollen quite badly as he did not apply anything. My grandfather said opium could help to reduce the pain caused by other insects such as bees and snakes as well.

However, my father, with his medic experience, did not agree with my grandfather as he was more into modern medicines than traditional medicines. But my father could not repudiate the idea that opium could help to ease pain. Sometimes, my father applied his medicine on my wound. I did not know what it was but I remember it was a white cream that looked like the present-day 'Counter Pain'. He squeezed the white cream out from a small finger-sized tube. He also stored some medicine at home for emergency use and sold them to people in cases of emergencies. Practically every night, there was at least one customer coming to buy his medicine. Sometimes, I helped my father sell Paracetamol and Penicillin as those two were in a very high demand.

"Dad, what is this one?" I asked my father when I first learnt how to recognize the drug.

"The white package is Paracetamol and the red package is Penicillin. Must be careful when you sell to people, okay?" my father pointed to the medicines as he explained what they were used for.

From that moment onwards, I remembered what my father told me, and seldom did I sell the wrong medicines to customers. The regular buyers also remembered the names and characteristics of the medicines after a while so if I were to give them the wrong one, they would

alert me. But that rarely happened. It was a really good business. Sometimes, when we were having our dinner, customers would come knocking at the door asking to buy the medicines. Sometimes, my father was so busy selling medicines that he could not have his dinner in peace.

Every now and then, patients would come over for injections when they were not feeling well. After an injection, my father would throw away the needle but kept the syringe. He boiled and dried it before keeping it in his medical bag. When he used it next time, he would take it out to boil it again. His medical bag contained many needles and a few rolls of bandages. When I first saw my father holding a needle, I was very scared but slowly, looking at him administering injections for his patients became a common sight in the house.

Confused Nationalities

~ ~ ~ ~ ~ * * * ~ ~ ~ ~ ~

One evening, as I was walking to Kaohin's house, I heard a commotion coming from the communal area. But I could not make sense of it. Out of curiosity, I decided to walk towards the source of the commotion. As I arrived, I saw about ten adults gathering at the communal area and drinking alcohol together. I must say the smell of the liquor was very pungent.

In the middle of the circular gathering, there was a gasoline lamp, two bottles of liquor and a plate of grilled meat. That lamp, coupled with the bright moonlight, was sufficient for everyone to see one another.

I stood there for a while, trying to figure out what they were talking about. One relatively young guy suddenly stood up and started to point his finger at his peers as he tried to balance himself. I reckoned he must be tipsy, if not drunk.

"Do you know that we are not any better than a homeless person?" he slurred his words as he pointed around, with a glass of liquor on the other hand.

"Yes! We have no nationalities. We have no place we could call home. We are neither Thai nor Lao," another guy responded, banging his fist on the floor.

"Do you know that my family will have an interview tomorrow to go to the US? This will be my second time going for the interview. If I don't pass the interview, I don't know where I will be," one guy spoke up in the midst of the commotion. Nobody seemed to care about what he had said. But surprisingly, the guy beside him patted his shoulder and asked why he had failed his last interview.

"The US officials did not give me any explanations why I failed the interview. They just said I could apply again next time," he answered. "My father-in-law said I should not go back to Laos even if my family didn't get to go the US. He asked the Mienh shaman and he said I would not prosper if I moved back to Laos. I will be stuck in Laos as a poor farmer for the rest of my life," he continued.

After that, I decided to head to Kaohin's house. But as I was walking there, the conversations of those adults suddenly made me think of an interview scene I had once witnessed. Scores of people held on to small black boards with their names written on them and posing in front of the camera. My father, being a translator, sometimes had to arrange the position of the black boards for them. Some just simply could not hold it straight up. Some refugees smiled at the camera while some looked very serious.

"Smile a little bit. If not, they will not allow you to go to the US," a husband advised his wife as she was standing in front of the camera.

Kaohin and I giggled to each other as the lady tried to force herself to smile. The refugees carried with them many kinds of documents. Some were sitting down while others were standing and looking around.

My father had a handkerchief with him to wipe the beads of perspiration that formed on his face in the hot weather. During the break, my father then called to me and Kaohin to have lunch with him. Some people also packed their food from home as the break was not long enough for them to go back. Many used banana leaves to wrap their food. At that time, it seemed that wrapping food with banana leaves was the only way of packing food.

As I reached Kaohin's house, the thought of the adults at the communal area immediately faded away. I asked Kaohin out with me to play our usual hide-and-seek game. As we were walking, Kaohin surprised me with a question.

"Do you know whether we are Lao or Thai?" he asked

"Hmm . . . Why did you ask me that?" I responded. This question had never crossed my mind before.

"My father and his friends were talking about it this afternoon. One of them asked me if our teacher told us about this in school so I got a bit puzzled," he continued with a hint of uncertainty in his tone.

"I guess we are Lao because my grandfather told me that we were from Laos. So I think we are Lao," I contributed my opinion but I was not sure myself. "As a matter of fact, I don't really know as well. Why are we not Mienh?" I asked Kaohin rhetorically.

At that time, the topic of nationality did not bother me at all. I was so carefree and to be frank, I did not even know what nationality was. I could not fathom why the adults were so concerned about that.

As we met our friends, Kaohin and I just dropped the topic. We did not talk about it anymore. We went on with our usual hide-and-seek game.

The New School Term

~ ~ ~ ~ ~ * * * ~ ~ ~ ~ ~

I had learnt many lessons and enjoyed myself immensely during that summer holiday. Although all the activities we had done during that holiday were everyday activities, I found something special about this holiday. Maybe it was because I felt more motivated to study after my first failure, or maybe it was because it was my first day of school after three months. The holiday had passed really fast. Time really flies when you are enjoying yourself. In just one week, it would be the new school term, where I would face my previous form teacher and a few classmates who were retained

together with me once more. I felt particularly excited about school as compared to last year.

My father bought me a notebook with a set of stationery. At the back of the notebook, there was a standard multiplication table that my father always asked me to memorize if I wanted to do well in Mathematics. The notebook was slightly smaller than an A4-sized paper. On its cover, there was a cute little bear pointing to the lines at the bottom of the book for me to write my name, subject, class and academic year. Inside the stationery box, there was a ruler, a mechanical pencil and a sharpener. Each of my brothers was given three notebooks with many more tools inside their stationery boxes. However, I was not jealous of them at all as I fully understood that they were academically senior.

Students in the refugee camp did not have to wear uniforms to school. We just wore T-shirts, shorts and slippers or sandals and carried bags. Everything was so simple. We all were dressed in what we usually wore every day. That was it! Our parents did not have to fork out extra money to buy new clothes for us. All the teachers in the school were also refugees so they understood the economic condition of everyone else.

When the morning of the first school day arrived, my brothers and I had to wake up early as usual and study, except that we did not have to go queue up for

water anymore. My father taught me the same things that he had taught me last school term. He held my hand and asked me to carefully follow him. I could feel that I was able to move faster than the last time. I was able to form the alphabets by myself with less supervision from my father. Once completed, I excitedly showed it to my father. Upon seeing it, he smiled and said, "Go on. That is the way." I felt very encouraged by him and I could feel an expression of satisfaction forming on his face when he said those words to me. My brothers were amazed by what I could produce on that piece of paper.

"Wow, you can finally write something," Kaova said to me.

But Kaeva was busy doing his own work. He did not bother about what Kaova and our father complimented me.

After breakfast, we walked together with other kids to school. The air that morning was very refreshing. The trees that we usually walked past last school term seemed taller and the leaves seemed thicker. Birds were flying from tree to tree above us while chirping merrily. In the last school term, there were no dustbins located along the road. But as I was walking from the camp site to the school this time, I could see three new green dustbins located along the road. Besides that, everything else remained the same.

On the way to school, some students bragged about their new notebooks and stationery. One boy who was from a relatively well-to-do family kept boasting about his new shoes. I guess he had the right to boast because his shoes were quite fashionable and well-designed. He was the only one who wore shoes while the rest of us wore slippers or sandals.

When we reached the school, we hung around for a while and chatted with one another. Many people I saw last school term still looked the same except for one. After examining her for a while, I realized that she was an ex-classmate. Previously, her hair was short but now her hair was longer and tied into a pony tail. She was now in primary 2.

When the bell rang, everyone dashed to queue up in front of their respective classes. As usual, when students were running, the whole place would be blanketed in dust. My teacher walked down the line to check our hair and finger nails. She smiled at me, giving me a look that said, "Welcome back, Sanva". After a few minutes, the whole school burst into the Lao national anthem while everyone stood still with two hands hanging straight down against the hips. At that time, we still sang the old version of the Lao national anthem. The assembly was only carried out on Mondays. For the rest of the

days, we just entered the classroom straight away after the bell rang.

Before the class officially started, the teacher asked everyone to stand up and introduce ourselves. However, I could only remember a few names. It was so hard to put my classmates' names to their faces. My form teacher still looked the same, with the same hair style and the same powerful voice. She even taught us the same thing as last time even though I could not remember what she had taught us exactly. I also felt that I could focus better and listen more attentively than last time. My eyes were glued to the board and followed the rod in her hand as she moved from left to right pointing at different alphabets. When she asked me to read the alphabets, I could confidently say them out loud.

"Sanva, can you read this alphabet to the class?" my teacher asked me.

"That is 'Kor Kai'" I read out.

"Can you read louder? I think not everyone can hear you," she looked at me, pointing her rod at the blackboard.

I then read out as loud as I could. When the teacher said it was correct, everyone in the class clapped. I was very excited and delighted even though I could feel my face burn with shyness. Since the previous year, that was the first applause that I had received from the class. That

was why I had not quite got used to the applause and praises.

"Thank you, Sanva," my teacher smiled.

Throughout the entire lesson, the teacher particularly targeted me, partly because I was her ex-student. I had found a new sense of excitement in this class. Slowly as time passed by, I became more and more eager to learn. I felt no more fear in me. I felt much more confident.

One thing that remained true about school for me was that the library was still something that I always looked forward to visiting after every class. As I stepped into the library, I felt that the bookshelves were emptier than last term but my favorite book was still at the same spot on the same bookshelf. Despite all those changes, the atmosphere was still the same. Many activities were still lined up for us. There was a new addition: a story-telling session. That activity became one of my favorite things in the library as the story teller was indeed engaging and all the stories that he narrated to us were very fun to listen to. One of the stories that he told us was the same "Xiang Miang" stories that my father had told me.

The library supervisor still remembered me. She smiled at me upon seeing me approaching her.

"Hello, Sanva. How are you?" Sister Kamdee asked.

"Hello, Sister. I am good," I replied.

"I hope you enjoyed your holiday. There are some new books at the other corner," she said, pointing her finger to the left.

"Thank you, Sister Kamdee. See you later," I said and proceeded on to my usual spot.

School in that year was simply more fun. I also found my teacher more caring. I did not have to be punished by standing in front of the class anymore. She also expressed a lot of concern and care for me when my hand was fractured.

That incident happened on one of the days I jumped up to get something from a tree on my way to school. As I jumped up, I lost my balance and fell down, landing on my left hand. As a result, my hand was wrapped in a plaster cast made of calcium powder. During that period, I was barred from eating food such as chicken, oily food, preserved food, ginger and even rice mixed with water and sugar. One of the days in the classroom, a classmate of mine teased and disturbed me about my fractured arm. The teacher asked him to stop several times but he still insisted on making fun of my arm. I could not do anything but just cried silently with tears streaming down my cheeks. The teacher was agitated by him and threw a box of chalk at him from a distance. Suddenly, the whole class was completely silent and the boy started to cry. I could feel that the teacher shared my sentiments.

She could not stand it any longer and asked the boy to leave the class immediately. She wiped my tears for me while asking the rest of the students to pick up the chalk that was scattered everywhere on the ground. For the first time, I could sense the warmth from my teacher and I started to love her more. Also, from that day onwards, that classmate did not dare to tease and disturb me anymore.

Fractured Arm

~ ~ ~ ~ ~ * * * ~ ~ ~ ~ ~

When my arm was healed, my father brought me to the main hospital in town to remove the cast. Extra care had to be taken with this cast as the white powder could easily disintegrate when it came into contact with water. Because of that, either my mother or my brothers had to hold the cast up for me when I was taking shower. Sometimes when I was lethargic and weary, I went without showering for a few days.

Inside the doctor's room, I was frightened at the sight of a tool that looked like a saw. When my father told me that the tool would be used to cut open the calcium powder wrapped around my arm, I was even more

petrified. All sorts of thoughts were running through my mind. What if it cut deep into my skin? What if my hand was cut off? I could feel my whole body trembling.

"Dad, I am scared," I told my father.

"It will be fine, son," my father consoled me as he rubbed my head.

"It does not hurt at all, boy," the doctor said.

To ease the fear within me, my father was inside the room with me throughout the whole procedure. However, I still felt a tremor of fear running down my spine when the doctor plugged the cutter's wire into the power socket and switched the tool on.

The loud whirring sound of the cutter itself was already enough to freak me out. I hugged my father tight and refused to hand over my arm to the doctor. It was only after much persuasion from my father that I reluctantly surrendered my arm to the doctor. The doctor handed over cotton to me and asked me to stuff it into my ears to block off the noise since I was too afraid. He also gave me a sweet to suck on. Throughout the whole operation, I hugged my father with my other hand and closed my eyes tightly, refusing to look at anything. My father patted my back and rubbed my head signaling that he was still there with me. After some time, my arm felt very light. The doctor asked me to take the cotton out of my ears and open my eyes. I turned around and

saw that the calcium powder was gone completely from my arm.

"Dad, is my arm okay?" I asked.

"Yes, it looks great! You see, it is not scary at all," my father said.

"It does not hurt also, right?" the doctor added, patting my back as he started to pack the machine away.

However, I could still feel a bit of pain as I moved my arm. It was very pale and a bit swollen as compared to my right arm. The doctor washed off all the traces of white powder and applied some cream onto it. When everything was done, he asked me to move my arm up gently while he formed a sling bandage around my neck and my arm. I felt so at ease at that moment. My father had a quick chat with the doctor. Then, we left the room after expressing our gratitude to the doctor.

When we reached home, my mother said I now could have my bowl of rice mixed with water and sugar. I guess she wanted to cheer me up. I stayed at home that whole weekend. I had not played hide-and-seek with my friends for many weeks so I missed all the good old days.

Deep inside my heart, I felt that I was being deprived of something; and that something must be hide-and-seek. However, I was not really sad as my father was always there with me to teach me how to read and write. I could feel that the progress of my study was going fast

as I could at least read a simple short passage then. My father said that I had to study hard if I wanted to read the "Xiang Miang" stories. He told me that reading was much more fun than listening to someone telling a story. I was so inspired by what he said that I studied very hard throughout the year.

By the time I went for the examinations, I already knew all the alphabets, read a passage and memorized all the standard multiplications. Never in my life was I so confident. When the results came out, I had passed the examinations with a high distinction and as a result, I was promoted to Primary 2 for the next school term. My brother Kaeva dirtied his pants as usual but this time round he only passed with a distinction, not high distinction. My brother Kaova also passed his examinations.

My father was very proud of us and pleased with what we had achieved. On the other hand, my mother was not as excited as she had never had a chance to go to school and therefore did not appreciate the significance of our academic achievements as much. Therefore, anything about studies was not in her topic of discussion or interest. When young, she had to take care of her brothers when they were toddlers and help out in the house and farm. Moreover, people often perceived it to be useless for girls to go to school at that time. There was

no point for girls to go to school because after marriage, they would move out to stay with their husbands and take care of children at home. As a result of that, my mother was illiterate. The only time she went to school was when the UN introduced a life-long learning program for adults. My mother enrolled herself in the course but all lessons were taught in the Mienh dialect. She had to bring my brother Kaova along with her to the class when he was still a toddler. There were also other adults and parents enrolling themselves in this course. After the completion of the course, my mother was the second top student in the class. But after a long time of not practicing how to write and read, she forgot everything.

Clothes Riot

~ ~ ~ ~ ~ * * * ~ ~ ~ ~ ~

I felt that the current school year passed by really fast. It was time for the holidays again. That summer, there was an incident that I will never forget. Beside the main market in the camp, there was this huge storage container with clothes, blankets and other necessities like shampoo and soap inside a dilapidated building. I overheard one of the refugees telling his friends that all those items were meant to be distributed to the refugees but the Thai officers had not done so. The refugees had to wait very long for these handouts. They felt that they had to stand up for what they were entitled to.

Therefore, on one of the nights, many angry refugees surrounded the building and tried to break through. The whole place was dark with flashes of torch light forming halos all over the place. It was very crowded. Some people hammered on the lock and some were trying to hack the wall apart with knives. People were screaming, shouting and cheering while trying to get into the container. Kids and adults of all ages were there.

Everyone squeezed their way in when the door was slowly opening up. Inside was full of clothes. In the ensuing pandemonium, my father quickly stuffed everything he could grab inside the bags we had brought with us and passed them to us. We quickly pushed our way out, brought them back home and ran back to the place again while my mother sorted out the clothes at home. The whole place was filthy with dust as people were running up and down. Some were carefully identifying and throwing away those items that they did not want. The whole mountain of clothes was slowly disappearing. I tripped and fell down a few times as it was simply too crowded. As people were busy taking the clothes, we heard a sound of a gunshot tear through the night air.

Someone bellowed "Police! Police!" repeatedly.

"Let's get out. Police is coming," someone shouted very sharply into the crowd, producing echoes in the container.

Upon hearing that, everyone dashed out of the container. Some fell down as they were running and were stepped on by others. I was so terrified by the whole scene. Beads of sweat were copiously rolling down my face and body, causing my whole body to become damp and sticky. I could feel that my face was red hot as I ran home. My father, my brothers and I gasped like athletes who had just completed their races. We looked into one another's eyes and started laughing at ourselves. We had never done anything together as a family before. I guess this was the first "activity" that the whole family participated in. Taking clothes illegally! In other words, we were stealing. After exchanging glances and laughing with one another for a while, we started to take a look at the condition of the clothes. Some were worn out but some were still in good condition. We threw away those that we thought could not be used anymore. My father also sat down and joined us in sorting the clothes. My mother collected those clothes that could not be worn anymore to re-work into something that might be useful such as cloths for wiping and so on. Some clothes looked great to wear but I hardly found any piece that suited me as many of them were either too big or too small.

As we were looking through the mass of clothes, Kaova shouted, "Money! Money!" as he waved the notes high in the air.

"I found money!" Kaova howled with excitement.

My father took a look and said it was Chinese currency. It was about five hundred Yuan in total. Everyone was over-joyed and my father told all of us to keep this a secret within the family. I found out the next day that those clothes had been donated from many parts of the world. Their owners had not needed them anymore so they had donated them to us, people who needed them more. We felt a bit guilty for stealing the clothes but since everyone was doing it, we found it perfectly fine and normal. Had we not done that, we might not have got our share as the Thai officers took a very long time to distribute them. My family had a lot of fun. The good thing was that the whole event did not turn into a stampede that injured someone when people rushed in and out of the storage area even though it very easily might have.

Market Place

~ ~ ~ ~ ~ * * * ~ ~ ~ ~ ~

One day, my mom and I went to the market that was about a fifteen-minute walk to the back of our block. I cannot remember exactly if this happened during a usual weekend in summer. Along both sides of a small pathway, there were a lot of people displaying all sorts of vegetables, chili, egg plants and meat. Vegetables were piled up in heaps like mountains. The chili was so red that when I looked at it, I could feel saliva pooling in my mouth. There were also all kinds of meat available such as beef, pork, chicken, cooked rats, plucked birds, sun-dried lizards and many other wild

animals. Sometimes, the butcher would kill chickens and ducks right on the spot at his stall. I observed him with a shudder of disgust and revulsion as he plucked out the feathers on the neck of a chicken and, with one practiced flick of the wrist, sliced it open with his sharp knife. As he did so, crimson blood started to ooze from the pitiful chicken's neck and flowed into a bowl half-filled with water. Even though it was not a pleasant sight to see, many people still stopped by to take a look as they walked past his stall. A lady covered her mouth and moaned softly out of disgust. Her whole face contracted as she moaned and wrinkles lined her face.

Wood used for fuel was also sold in stacks along the road. As people were strolling about, talking, bargaining and loudly touting their wares, a din engulfed the entire open-air market. What added to the beauty and vivaciousness of this market was a row of trees standing firmly along the path where sellers had set up their stalls and booths.

Sometimes, people fought in the market. One day I went to the market to help my mother to get something, I saw two middle-aged men in a quarrel which escalated into a fight.

"It is my hen," one guy shouted, pointing his middle finger at the other party.

"No way, man! Don't you see the tail? I purposely cut it off to label that it is my hen," the other guy shouted back, looking straight into his opponent's eyes.

The first guy was so incensed that he punched the other in his face, snatching the hen from him. They began fighting and rolling on the dusty road as if they were putting up a show for passers-by to see. Both of them hurled vulgarities at each other. The hen, suddenly freed, wandered off somewhere but they did not care and continued to fight with each other. Filth was all over the place and people were surrounding them as if they were in the center of a performance stage. Some cheered and encouraged them to fight on. After a while, some people rushed in to stop them. In the market place, once in a while, fighting like this would happen. To some, it added color and vibrancy to the market. However, it scared some customers, causing vendors to lose their business.

MSG or Sugar

~ ~ ~ ~ ~ * * * ~ ~ ~ ~ ~

At that time, eating rice with plain water mixed with sugar was a very popular thing to do among kids. My brothers and I would sometimes have that for our lunch. "Sweet and kids always go together," my mom said as she passed us our bowls of rice. On one of the days, when I was in the market with my mother, she gave me money and asked me to buy candles at the other end of the market. Instead I used some of the money to buy sugar. When I went back to my mother, I told her that I had accidentally dropped a coin into the drain beside the walk-way. My mother scolded me for being so careless. She gave me money to replace the one I

119

had "lost" and sent me off again. I hid the sugar from my mother and did not tell anyone about it. At that young age, the feeling of shame and guilt of telling a lie never crossed my mind. My parents constantly taught their children not to tell lies and not to do anything that was not upright. However, somehow the teaching had not penetrated my skull. Maybe the desire to eat something sweet overrode everything.

I did not even show the sugar to my brothers and my friends even though I knew that they would have loved a portion of the share. I took it out one night and started to eat it. It was not sweet. It tasted totally different from the sugar that I normally had for my lunch. However, I convinced myself that it was sugar and I ate it almost all by myself. While eating and licking my fingers, I was spotted by a distant relative of mine, who had come to retrieve something from my mother. She walked up to me and asked what I was eating. She had taken me by surprise and I quickly told her that I was eating sugar. She bent down, took the sugar bag from me and started to examine it.

After a while, she shouted, "This is not sugar! It is MSG! Go and rinse your mouth now."

"No. Give me back. It is sugar," I was still trying to convince myself that that was sugar although I was not really sure. I was slightly angry when she took it from

me. I was shorter than my cousin so could not jump to catch the sugar bag from her hand. Every time I tried to jump, she would raise her hand higher.

I was quite stunned by my cousin's outburst. She then rushed to my mother and told her that I was eating Monosodium Glutamate (MSG). They quickly asked me to throw it all up and to rinse my mouth with water. Luckily, my mother did not ask me where I had got it from. I really could not distinguish MSG from sugar as they both looked the same to me. They both were grainy and crystal white! My mother then educated me on the difference between the two. She took out sugar and MSG from the kitchen. She asked me to sit down beside her and told me to look at the size of sugar and MSG crystals. Indeed, the crystals of MSG were longer than that of sugar. Also, sugar was much finer.

Throughout the night, I felt that my mouth was rough and dry. My whole family expressed amusement at my stupidity. I also laughed along with them. The next day, all of my friends knew about the incident and they all started to laugh. Surprisingly, Kaohin was the only one who asked me where I had got the MSG from.

"Do you know that eating too much MSG will make you become retarded?" Kaohin asked me.

"I thought it only weakens our bones," I added my viewpoint.

I had learnt that from adults. Many of them kept saying that MSG was not good and it would cause the bones to weaken and "rot" faster. I did not know where they got the information from. I had heard from some of them somewhere and remembered it. Even though there were rumors about its bad effects, many people still used it in their cooking. My family was one of those using it all the time.

"Yes. It weakens your bones and will slowly cause your brains to rot," Kaohin continued to provide me with his facts. For once, his face looked so serious. The crescent-shaped face had somehow expanded like a partially-full moon.

"I saw the pictures from our school library. I will show them to you one day," he continued to reassure me that he was right.

I still did not fully believe him but looked forward to him showing me the pictures to prove his point.

Mother

~ ~ ~ ~ ~ * * * ~ ~ ~ ~ ~

My mother was from a relatively large family. Her parents gave birth to six children, and my mother was the fourth child. On top of that, they had adopted a girl and a boy. They adopted these two children before they had the rest of the children of their own. Initially, it was hard for my maternal grandmother to conceive. The Mienh people believed that by adopting a child, they could then give birth to their own children later on. At that time, my maternal grandparents also needed someone to help out in the daily farming and household chores. Therefore, they adopted my oldest uncle and aunt. The superstition turned out to be true.

A few years later, my maternal grandmother gave birth to six children.

Shortly after my maternal grandfather married my maternal grandmother, he also married another wife. His second wife gave birth to two children. My mother told me that my grandfather was hardly at home. The farm was very far from the residential area so sometimes he would have to stay overnight at the farm. He also liked to drink and fool around with other women, sometimes involving himself in extramarital affairs. Being hot-tempered, he hit my maternal grandmother very often. To my mother and her other siblings, domestic violence was a common sight. When violence was too much to bear, my mother would seek comfort in her older sister. But for my adopted aunt, she could not stand the unfair and cruel treatment so she decided to leave the family and elope with her boyfriend.

My maternal grandfather made his adopted son marry his first biological daughter. That means my adopted uncle married my own aunt. My maternal grandparents and almost all of their children, except my mother and the adopted aunt, eventually emigrated to and settled in the US.

My mother got married when she was sixteen years old. I must say that my mother was a very beautiful woman. She had very sharp and fair features. Her

long hair was silky and straight. Like all her friends, she also liked to apply some light make-up. Whatever cosmetic products that were advertised on Thai radio, most of her friends had them all. I guess advertising through this media channel was a very effective way of marketing cosmetic products at that time. However, unlike her friends, my mother did not go overboard with her make-up. I once saw that she only had moisturizer and a small pack of powder in her sewing basket. But her friends had a wide array of those and much more besides.

My mother still kept some of her old photos. Before and even up to the point when she got married, she always appeared to be very happy and pretty despite the hardship and the domestic violence she had observed when growing up.

"Mom, when was this one taken?" I held up a photo and asked her.

"I think it was taken behind the rice field in Luang Prabang," she replied.

"How old were you at that time?"

"Hmmm . . . I guess I was about eight years old. I am not sure too," my mother answered with some hesitation in her tone.

"You were like a little girl, mom. Very cute and pretty. Did you always have to wear the Mienh costume? Wasn't

that hot? Who is that girl holding on to your hand?" I knew that I asked her quite a lot of questions. But I was simply curious. My mother answered me patiently as she sewed the clothes and adjusted the stool for my sister.

"Look at this picture. You and dad! How old were you when you got married?"

"Oh . . . that one was in Nam Yao refugee camp. We had just got married and your dad had asked me to take a picture with him. Well, I was sixteen years old at that time," my mother answered me softly. She somehow appeared to be very shy as I could tell from her tone and expression. However, without me asking, she went on and talked about how she had met my father.

"I only met your dad seriously twice before I married him. At that time, I didn't even know anything about love or marriage. When your grandfather asked me if I wanted to marry, I remember I didn't even give him a reply. I ran away to your aunt. But I do remember that the thought of me marrying a man really scared me a lot. Some of my friends got married earlier than me. But I was just really afraid," my mother went on telling me about her thoughts and feelings.

"Why did you still marry dad then?"

"Your paternal grandpa came to talk to your maternal grandpa a few times. Your maternal grandpa felt that your dad was a good person so he asked me to

marry your dad. At that time, your dad also personally came to talk to me once after his work. Your dad also knew your uncles so he asked your uncles to convince me as well. I always thought that your dad was flirtatious as I often saw him and his bunch of friends singing on the mountains trying to woo those girls who worked in the rice fields. Your dad actually had a few girls that wanted to marry him. I must say that he was quite handsome and smart. That was why I was a bit afraid to marry him too. In fact, your aunt asked me not to marry him. But in the end, I still married him," my mother looked at me only once or twice as she shared this with me. Her eyes were fixed on her sewing.

My brother Kaeva came over and sat beside us. He also listened to the stories. He leafed through the photos and looked at them. He smiled at some and looked at others intensely. I could not remember what I asked her but she went on to tell us about her childhood.

"When I was at your age, I had to help your aunt to babysit her babies. If not, no one could work in the rice field and bring food back home. All of your uncles went to school and by the time they came to the rice field, it was almost dark. So they could not do much. Your grandfather said that girls should not go to school. It was a waste of time. That was why your aunt and I didn't manage to go to school. It was very rare for a girl to go to

school at that time. During the war, I even had to carry your aunt's babies around and run through the dense jungle. When they cried, your grandpa rapped my head. He said I could not take care of the babies well. When it was cold at night, I had no choice but to wrap my shirt around them. Your aunt also had to take care of her own small baby who was only a few months old. The babies urinated all over me," she paused for a while as she lifted my sister and began to breast-feed her.

"But your aunt is very nice. We are very close. I remember that whenever she had a chance to follow your grandpa to town, she would buy back some snacks for me. There was one time when we went to town to sell some vegetables and your aunt bought me an ice-cream. Even now as she is in the US, she still helps me a lot."

As I listened to my mother's stories, I could feel the sadness in her voice. Her voice was very soft and low.

Mortar and Pestle

~ ~ ~ ~ ~ * * * ~ ~ ~ ~ ~

One day, my mother and my aunt (Uncle Saengfou's wife) quarreled over the use of a set of mortar and pestle. As I watched the whole dramatic scene unfolding, I felt a bit scared. However, I didn't cry or feel the need to run away. This mortar and pestle had been bought by my grandfather and it was supposed to be shared since we lived in the same household. Once, when my mother had finished using it to make chili paste, she cleaned it up but neglected to put it back where it belonged. Because of this, my aunt could not find it and started to scream without even asking if anybody had seen it. When my mother heard her scream, she

immediately passed it to her and apologized a few times. Unfortunately, her apologies were not enough to mollify my irate aunt.

"Why don't you put it back when you are done?" my aunt screamed, glaring fiercely at my mother.

"I was busy and forgot about it. So sorry about that," my mother answered with her gentle voice.

"Do you think this mortar and pestle belongs to you and your family alone?" my aunt pointed at the mortar and pestle in my mother's hands. After she said that, she suddenly snatched them from my mother. She aggressively thrust the pestle at my mother and flung it on the ground as soon as she had finished accusing my mother.

Being soft-spoken, my mother uttered something which I could not really hear. She then broke into tears and turned away. But my aunt was not done. She pulled my mother's hair and shouted loudly, "Answer my question. Does this belong to you alone?"

My sister, who was sitting on the stool, started to cry. Then, my father rushed into the kitchen and stopped the altercation. He bellowed at my aunt, "What is going on? Are you out of your mind?" My aunt stared at my father for a while and she turned away without saying anything.

"Do you want this? Take it away," my father retrieved the pestle and passed it to my aunt forcefully.

My grandfather walked in and enquired about the situation. My father said, "You ask her yourself, dad."

"I knew it is about this again. Why not you take it and use it all you want?" my grandfather shouted and glared at my aunt. I could see from his heavily lined face that he was livid with disappointment and anger.

My aunt stormed out of the house with the mortar and pestle. She was grumbling and muttering something that I could not comprehend. However, I knew that she was cursing to some random spirits as I managed to catch some familiar words. She looked up to the sky, and raised the mortar and pestle up in front of her face, mumbling to herself. Other refugees came out of their quarters and looked at her.

"San, what is your aunt doing?" a friend of mine came to me and asked. He shook me on my shoulder, hoping to get an answer from me. I simply replied, "I don't know." And I ignored him as we watched my aunt. My aunt smashed the pestle against the mortar a few times and went back to the kitchen with a stern face. By the time she walked into her quarter, my mother was already out of the kitchen. She was with my sister and breastfeeding her. When I went over to my mother, I could still see some tears in my mother's eyes. Her eyes were swollen.

Sister

~ ~ ~ ~ ~ * * * ~ ~ ~ ~ ~

When I had nothing else to do, I would sit down and play with my sister, Meiva. She would sit on a stool that my mother had turned over and put a cushion around so that she could sit comfortably. Chuckling joyously, she squeezed my finger every time I handed it to her. Her eyes were beautifully big and her cheeks were soft, and I often pinched them. She just looked so adorable and angelic. She was very precious to everyone in the family as she was the only daughter. I truly enjoyed playing games with her, particularly when I clapped my hands and she would blink her eyes and then laugh gaily.

My parents had always longed to have a daughter. They had tried various traditional ways in hope of conceiving a daughter, one of which was for the mother to tie her skirt around a tree and constantly pray for a daughter. My mother went through a lot of these kinds of practices. They even did some of these before they gave birth to me but to their disappointment, I was a son.

Whenever I was taking care of Meiva, she always seemed to be very joyful. Never once did she cry when I was with her. In front of her, I stuck out my tongue and encouraged her to imitate me.

"Look at this. Follow me. Follow me," I told her, pointing to my tongue.

She laughed away happily. I also blinked my eyes and asked her to do the same thing. However, this one was not as successful as sticking out the tongue. One day I put my finger into her mouth and she bit it. I tried to pull it out but it was clenched too tightly between her tiny teeth. I was just testing if her teeth had grown any bigger as compared to the last time.

"Mom, she is biting me," I screamed to my mother sitting beside me.

My mother quickly turned around and gently pulled my finger out. It was red and Meiva's teeth marks could be seen clearly on my finger. It was painful indeed but

I still continued to play with her, teaching her all sorts of signs hoping that she could imitate me. My mother scolded me when she saw what I was trying to teach my sister. My mother said they were crude and inappropriate. Feeling deflated, I just left.

Sometimes when my sister cried incessantly, my aunt would come and scold my mother for allowing the din to disturb the peace. My mother would just keep quiet and continued to do her own chores pretending nothing had happened.

My sister was very cute. I liked her pinkish cheeks a lot. There was a small dimple on her left cheek and I often poked it gently with my finger. Her bright beautiful eyes always darted intelligently and curiously this way and that and watching her, we were enthralled. Her hair was curly and soft. Whenever she sat on the stool, she would flap her hands merrily, screaming with joy.

Income

~ ~ ~ ~ ~ * * * ~ ~ ~ ~ ~

For many refugees in Napho Camp, the main income came from overseas. A lot of the refugees would send their hand-made items such as bags, clothes and ornaments to their relatives and cousins in the US and asked them to help sell the crafts to other Mienh people living in the US. The money would then be sent back to them in the form of a check. During that time, there were already many people who had migrated to the US.

My father worked in the hospital but took time off to make the ornaments too. At that time, my family's quarter seemed to be one of the biggest ones. A few

refugees came to the quarter to work for my father making these too. Among them, there were a couple of Hmong people. I remember that Kaova was very interested in learning and helping my father. He assisted my father in a lot of his work. In fact, most of Uncle Saengfou's sons were also very skillful in making the ornaments.

"Dad, who do you sell all of these to?" Kaova asked my father. I was beside them doing the math questions that my father had given me a week earlier. I had asked my father the same question before so I felt very much tempted to reply on father's behalf. My father then replied to Kaova's question exactly the way he had explained to me.

Once, my father and I went to a Thai officer's house. He operated postal services in his house. He helped the refugees send parcels to the US and when he received checks, he would contact the recipients and pass them the money in Thai Baht. This officer surely had a good business. Everyone in Napho Camp used his service. He was a very close friend of Uncle Saengfou's. I often saw him at our quarter on weekends. Sometimes, he would drink with Uncle Saengfou. Whenever he got drunk, he would be talking very loudly. He started to ask the kids to come near him and said that he was our "father". He also went into long lectures teaching us to be good

kids and to always listen to our parents' teachings. Sometimes, he would give us one Baht each to spend.

Whenever he got really drunk, his son would come by to pick him up. In fact, his son also had an electronic store at Napho Camp. He provided radio and TV repair services. Many of the older girls were crazy about him. Sometimes, they bribed kids like me and my friends with candies asking us to send letters to the man on their behalf.

The Hmong and the Mienh Culture

~ ~ ~ ~ ~ * * * ~ ~ ~ ~ ~

During my last holiday at Napho Camp, I found that I could speak Hmong more fluently. Hmong is another ethnic group just like Mienh. In the school and in the camp, I had the chance to interact with a few Hmong friends. My parents also knew how to speak Hmong, partly because they interacted with them quite often. At that time, Hmong people were more affluent. Therefore, we had to favor them by trying to pick up their dialect. My mother sewed clothes and sold them to the Hmong ladies, which they used to tie around their waists to serve as belts. This formed part of a Hmong lady's outfit. When they tied the belts, they

often left the two ends of the clothes dangling behind like pigs' tails. These clothes usually came in three different colors: pink; green and purple. But the most common one was pink.

Just a few blocks from where the Mienh lived was the enclave of the Hmong. The percentage of Hmong refugees was much higher than Mienh and other small ethnic groups combined. Because of our constant exposure to and interactions with the Hmong, almost every Mienh could speak Hmong at that time. My parents spoke the Hmong dialect so fluently that the Hmong could not tell that they were Mienh. They possessed the Hmong accent and their gestures really made them look like the Hmong people when they spoke. We had been told by our parents that the Hmong men were very hard-working and clever. From my own observation, that statement was true. Many of them were teachers and top students in the school. My father also said that they could speak English very well.

The Hmong culture seemed to be richer compared to the Mienh's. They were dressed in their traditional costumes in their daily life but not the Mienh. The Hmong New Year celebration was very vibrant. All of them were dressed up in their beautiful costumes. As the loud music played, many couples went to the middle of an empty field with a ball and stood about five meters

apart from each other. They then started to toss the ball back and forth to each other following the beat of the music. If anyone dropped the ball, he or she had to sing a song as a forfeit. Sometimes, the "victim" had to do whatever the partner requested. I attended the celebration once as I had been invited by my Hmong friend. At that very young age, I felt so embarrassed when I dropped the ball. I was not asked to do anything as they thought I was too young to be able to sing. In the evening, there was a concert as well as a singing contest. The Mienh New Year, sadly, was nowhere as fascinating as the Hmong New Year.

During the Mienh New Year, we will worship our ancestors a few days before the actual New Year day. On the actual day, we will wake up early in the morning before sunrise to worship our ancestors once more. After that, we will make the "red" eggs to decorate the houses and give to friends as gifts. Those eggs represent prosperity and joy. For our New Year, we believe that one should clear all his debt before the New Year in order to move on with life peacefully and successfully. Also, on the first day of the New Year, one is not allowed to spend any money as it is a superstition that he would keep having expenses for the rest of the year if he were to do so.

During that holiday, I also found that taking photos with beautifully painted and decorated walls as a backdrop was really popular among many young adults. Most of the walls had nature scenes on them. However, the photos that resulted after developing made them look as if the nature was so real. My family took a few shots. When a young man took a photo with a young woman, the whole crowd would tease them. Sometimes, the teasing would turn into reality as a few pairs eventually turned into couples and got married.

Last Day of Napho Camp

~ ~ ~ ~ ~ * * * ~ ~ ~ ~ ~

The holiday in 1994 was very different from the other holidays. Before school started, there came shocking news to the refugees in Napho Camp. We were notified that we would have to leave this refugee camp in about three months. Everyone was in a state of shock as they had to make a decision about where to go next. My father had to work very hard again to be a translator for the UN helping people who wanted to go to different places. Because of my father's achievements and outstanding contributions, my family was offered an opportunity to migrate to the US, which was apparently the top choice among all the refugees. However, my

father was still required to go for the interview as a form of formality. This was when my grandfather argued with my father and Uncle Saengfou as my grandfather was adamant about going back to Laos.

When my parents were in Vinai Camp, they had also been given a chance to migrate to the US but my father had to decline the offer because of my grandfather. At that time, my mother's parents encouraged my mother to follow them to the US. Her father even asked her to divorce my father and go to the US with them. However, my mother did not go because at that time she had already given birth to my brother Kaova and she loved my father very much. Hence she did not have the heart to abandon her husband and son, and leave for the US to begin her life afresh. My mother argued heatedly with her father over the decision that she had made. Everyone in her family said that she was stupid and ungrateful not to follow them. She was under a lot of pressure but my father was always there for her. Instead of asking her to stay back in the camp with him, my father, at that time, showed that he would respect whatever decision that my mother made. As much as my father would like to migrate to the US, he could not leave his father behind either. Therefore, my father fully understood what my mother was feeling but at the end, everything

was solved peacefully. My mother decided to stay back with my father and her son in Vinai Camp.

During that unsettling time, the classes were running irregularly. Teachers were absent without due notice. Attendance was not taken at all. This was a perfect chance for lazy students to miss school. Every household was busy filling up their applications to migrate to the country of their choice. The Thai officers said that if we did not move out by the end of 1994, our food supply would be cut off and those who still remained in the camp would not be given any benefits by the host country if they chose to stay back. The refugees would not be granted citizenship either. Some people said that those that remained in the camp might be jailed and executed. As such, everyone was very afraid.

Once a vibrant and peaceful place, Napho Camp was now in a state of chaos. People started packing up their belongings and the Thai officers began to tear down the living quarters. Those items that were too bulky and heavy to bring along, the refugees would sell to the Thai people. The items that could not be sold were either burnt or thrown away. The whole place was incredibly dusty, and everyone was very gloomy about moving out of this camp which they had called home for about five years. The day before we left, my parents cleared everything in our home and our quarter was also demolished.

Although I was only seven years old, I could feel the sense of sadness upon leaving this place. All of my friends were equally heart-broken when we knew that we would not see one another again. Kaohin sat beside me and we cried together on the night before our departure. Other friends also looked cheerless and down. We asked one another where our families were going to.

"It is very sad that we cannot go together," a friend said.

"Yes, it is. We may not get to see one another anymore. We cannot play all the fun games anymore," Kaohin added with his sad tone and his face looked distraught.

As we sat down facing the pond, we started to reminisce about all the good old days that we had spent together. Some incidents made us laugh while some made us not want to leave this place. At that young age, the thought of keeping in touch via any means did not cross our minds. All we knew was we would not meet one another again. I remember that only two boys, who used to play hide-and-seek with us, were migrating to the same place as my family was. But I was not close to them. Some were migrating to Laos but to different provinces while some were heading to the US. Although we did not really know what friendship was at that time, the impending "loss" of our friends, our good old days

and all the activities that we used to play together were enough to break our hearts.

On the night of our departure, we slept in tents. I could not sleep very soundly as I kept fidgeting. I could feel that my brothers could not sleep well either. Strangely, my grandfather was very quiet, unlike the other nights when he at least told us some stories before we fell asleep. I guess he was sad at the thought of leaving this camp too. No one really knew what awaited us. But one thing my parents knew for sure was that even though they could not go to the US, they were grateful that they would no longer be stateless.

When the morning arrived, everything looked very different from what it used to be like. The golden sun rays slowly illuminating the horizon no longer looked the same. They had lost their beauty. They contained a tint of sadness and impending loss. Even the chirping of the birds sounded so sad, not as merry as before. The entire camp was empty as some refugees had already left before that.

Later, as I boarded the bus, I felt like I was being held back by an invisible thread. My heart was getting heavier with every step I took up the steps of the bus. I was reluctant to get onto the bus. My brothers and their friends cried as they bade farewell to one another. When I finally stepped onto the bus, I moved slowly towards

the rear. As I peered through the glass windows from my seat, I could see my reflection telling me not to leave Napho Camp. All along, I had always thought that this kind of emotion only belonged in Thai drama series but I was feeling it now. The shows that I watched had turned into reality. It was happening to me right there and then. I guess it was happening to all the refugees that had to part from this camp and their loved ones too.

When everyone was finally on the bus, the driver started the engine, signaling that the place we used to live, love, fight, learn and grow up in was going to be in the past soon. Everyone waved at the now vacant, desolate looking homes, bidding farewell to the place they used to call home as the bus juddered noisily down the dirt track, leaving the dust behind to cover Napho Camp. All I could say to my friends and the camp was "Good bye!" I said this phrase silently to myself as most of my friends had already left before me. I could feel tears start to build up in my eyes as the camp slowly disappeared from view, enveloped by distance and dust. Deep inside my heart, I truly hoped that one day I could return to this place and meet all my good friends one more time.

"Good bye, Napho Camp!"

~ ~ ~ ~ ~ * * * ~ ~ ~ ~ ~

Dedication

~ ~ ~ ~ ~ * * * ~ ~ ~ ~ ~

I would like to dedicate this *Diary* to my family whom I always know I can never thank enough.

To my father, you are a truly brilliant father. You might have been occasionally harsh on me when I was younger. But, I know that behind every harsh word and look lie your love and good intentions. From the age of fourteen when I first got my scholarship to study in Vientiane, you have given me freedom to choose my way in life. But I always know that in the past twelve years, even though we are not living together, I feel your love and support in everything I do. This *Diary* is for you, dad. Your parental guidance has played a major role in shaping my character and life.

To my mother, you are my role model in every sense of motherly love. Despite your illiteracy and the gender discrimination you have experienced, you have never given up hope of seeing your children do well in school and in life. You are not a traditional mother. In spite of so many obstacles, you are still working very hard alongside father to bring home an income and provide the best meals on the table for your children. Your love towards us transcends your educational and social

background. The warm smile behind your soft and quiet demeanor is what I find peace in when I feel there is too much for me to shoulder. This *Diary* is for you, mom.

To my brothers Kaova, Kaeva, Souva and my sister Meiva, thank you for being so much a loving and accommodative part of my life. Since young, I have often gone on my own way without giving you guys much thought. For all my thoughtlessness, I apologize. We have not stayed together as a complete family for about twelve years but I always know that we are united and connected by a strong bond. I see each of you in so many of my most precious childhood memories. This *Diary* is for you guys, too.

Last but not least, to my grandfather, you are awesome. I have been privileged growing up with a caring and knowledgeable grandfather like you. Many stories that you shared with me still linger in my mind, fresh as the day I listened, breathless, wide-eyed and enthralled as you wove your magic with words. Some days I feel that I must turn back the clock and live back in Napho Camp once more to listen to you once again. You are old now but still your cheerful smiles behind those wrinkles have never been a barrier in our communication. This *Diary* is for you, too, grandpa.